The Art of
AUTOFOCUS
PHOTOGRAPHY

The Art of AUTOFOCUS PHOTOGRAPHY

MARC LEVEY

AMPHOTO
American Photographic Book Publishing
An imprint of Watson-Guptill Publications/New York

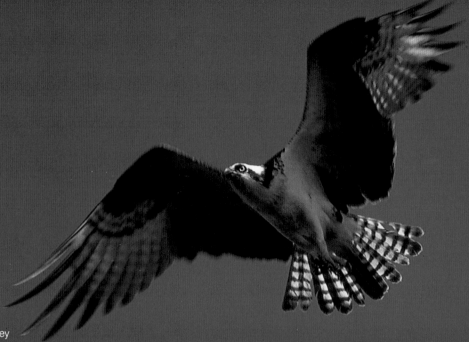

First published 1988 in New York by AMPHOTO,
an imprint of Watson-Guptill Publications,
a division of Billboard Publications, Inc.,
1515 Broadway, New York, NY 10036.

Library of Congress Cataloging-in-Publication Data

Levey, Marc.
 The art of autofocus photography.

 Bibliography: p.
 Includes index.
 1. Autofocus cameras. 2. 35mm cameras.
3. Photography. I. Title.
TR260.7.L48 1988 778'.28'22 87-37423
ISBN 0-8174-3300-7
ISBN 0-8174-3301-5 (pbk.)

Manufactured in Japan
1 2 3 4 5 6 7 8 9 / 92 91 90 89 88 87

CONTENTS

1 WHY USE AUTOFOCUS?

Autofocus, along with other automated functions, demonstrates to millions of picture takers that good photography is something other than a mysterious combination of high-level physics and chemistry. It is a reflection of the photographer's perceptions and interests. Automation makes possible a shift away from the technical processes by which a picture is made to more fundamental considerations of content and purpose. While the autofocus cameras are not as automatic as their name suggests and their features require some conscious manipulation and concentrated use, they do free the photographers from many routine functions and allow them to begin with the question, "What do I want this picture to say?" rather than, "How should I take this picture?"

Purists have regarded focusing, the last and perhaps most basic purely manual activity left to the photographer, as a sacred link with the past—with the brass, chrome, and glass era they insist produced the only photography worth mentioning. Automation will not guarantee memorable pictures—far from it—but I am convinced that automating routine camera functions such as focusing will benefit most photographers. Why should we worry about loading, winding, and rewinding film or tinkering with the speed setting and

Fast-paced photography of sporting events is made more practical using autofocus. In this instance, the photographer panned along with the movement of the speedboat while autofocusing. If this kind of photography appeals to you, you'll need to practice keeping the autofocus rectangle centered on moving subjects. Once you've mastered the technique, the action photography will seem much easier.

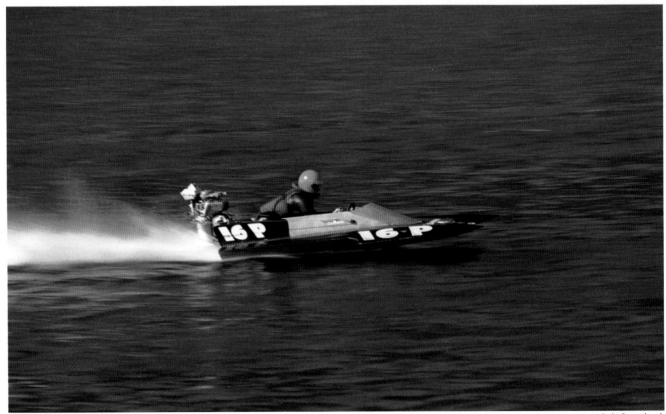

Bob Baumbach

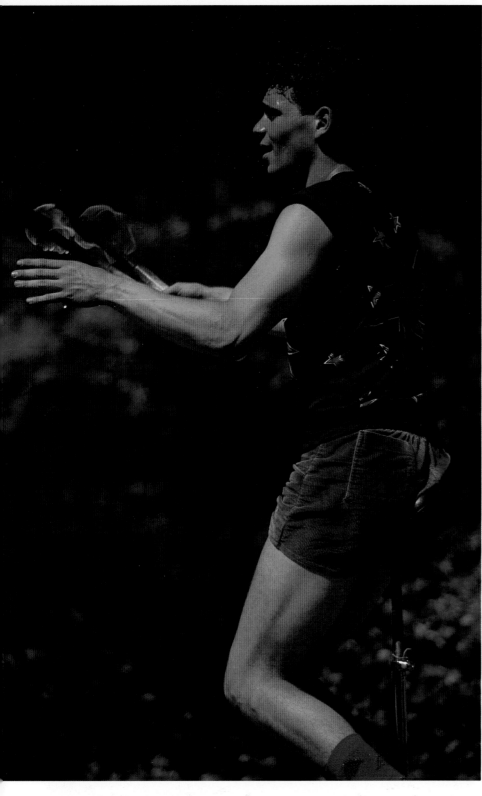

Action photography is a natural application for autofocus cameras. I used relatively fast film (ISO 400) that permitted the programmed meter to select a motion-freezing shutter speed.

flash setup if automated systems working under our direction can do these jobs as well as or better than we can? Even some high-order camera functions such as light metering and focusing, which directly influence what the photographer communicates, can be automated with positive results. Automation does demand that we trade off some flexibility for operational speed and convenience, but I believe the advantages of such a swap outweigh the liabilities, as long as a manual override is available for photographers who want it!

My perfect autofocus system would operate at the speed and discrimination of a well-functioning human eye, be able to operate in near-total darkness and at very low subject contrast levels, be silent or nearly so, and be small and lightweight—all at a cost competitive with that for manual focusing systems. We're not quite there yet, though some autofocus designs are coming surprisingly close to these ideals.

Most important to the greatest number of users, high-grade autofocus is much more precise than manual focusing. Sadly, many photographers are very sloppy when it comes to focusing. They just find what they think is sharp focus and go their way, rarely bothering to fine-tune the initial focus. The fault lies not with the manual focusing system but with the user. On the other hand, autofocus systems found in top-end compacts and autofocus SLRs deliver astonishingly precise focus within their design limits. As autofocus sensors and associated electronics are refined, they will be able to achieve sharp focus on lower-contrast subjects and in lower light levels than any previous man-made focusing system. In fact, some types already outperform human vision in such special circumstances as total darkness. These devices use focusing technology not dependent on visible light at all.

Another positive characteristic of autofocus is its repeatability. I'm satisfied that the best of the autofocus cameras will deliver sharp focus again and again, while many photographers using manual focusing will fail to achieve critical focus on the same spot nearly as often. Experienced photographers using high-quality 35mm rangefinders or SLRs can return to the exact focusing spot on a particular subject about 70 percent of the time. For the less proficient, the figure is closer to 50 percent. A 95 percent repeatability is documented with novices using a good autofocus SLR. The repeatability percentage drops for inexpensive zone-focusing autofocus compacts, or in dim or low-contrast situations, but even autofocus cameras with as few as eight zones have a repeatability of around 70 percent, the same level as the best of the nonautofocus cameras—an impressive performance.

What is so important about absolute precision and repeatability? Repeatability is important because you can return to the exact point of focus over and over again. In low light, when the lens is being used wide open at its

As I drove through the center of Johnstown, Pennsylvania, I noticed this scene out of the corner of my eye. As luck would have it, I hit a red light directly opposite the little park. Before the light changed, I managed to grab three quick shots with the autofocus compact I always keep beside me on the front seat.

Chandra Swami, M.D.

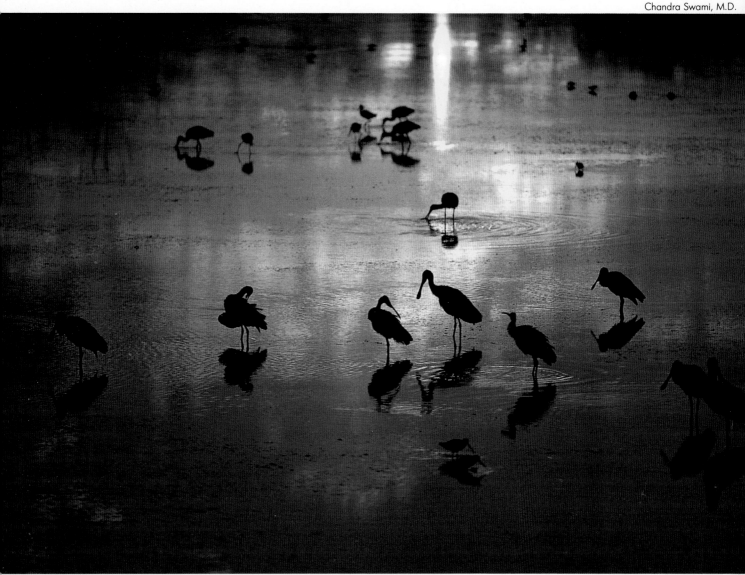

I've always had problems focusing in marginal light. Although autofocus does have absolute low-light limits unassisted, it's still a lot better at focusing a lens than the naked eye, especially in low light. For many of us, accurate focusing of dramatic scenes such as this is made easier and more consistent with auto-focus.

I think the two people in this image make it more than a typical vacation shot. They provide scale and secondary points of interest. Combine the ease and dependability of autofocus with a good sense of design, and pictures like this will add to your portfolio.

Richard L. Crowley

I've always been attracted to strong vi-
sual contrasts, so it's no surprise that my
eye was drawn to autumn's last hope.
The seemingly defiant golden leaves of
a solitary tree standing out against oth-
ers pulled me in. Painters can easily
conjure up a scene like this in their
studio. Photographers aren't that fortu-
nate; they must play with the visual
cards they are dealt.

maximum f-stop, moving from one subject to another and then back can be very time-consuming and difficult if you are forced to refocus manually every time. With a sensitive autofocus system, however, you can be confident of repeatedly achieving the same sharp focus. I know from experience that my autofocus camera does this far better than I can when I'm using my top-of-the-line manual-focus SLR.

Repeatability is important when you use long telephotos or do closeup work with macro lenses because in both instances the lenses being used afford razor-thin depth of field, particularly at medium or large f-stops. You soon learn that autofocus's repeatability vis-a-vis manual-focus systems only holds true for the best and most competent autofocus cameras. If you use lower-priced autofocus cameras, this advantage disappears or is even reversed in favor of manual focusing.

How the Autofocus Works. Almost all compact autofocus focusing systems operate by sending out an invisible infrared pulse that measures reflections off the subject in order to position the lens accurately. Light levels or subject contrast do not materially affect the performance of such systems. Though generally a good deal less accurate than the SLR's contrast-comparison focusing method, infrared usually does a good enough job to meet its design goals.

Unlike autofocus compact cameras, all current autofocus SLRs utilize a focusing system that is dependent on the presence of adequate levels of visible light to focus the lens accurately. Present autofocus systems can focus down to light levels requiring an exposure of 1/2 sec. at f/1.4 with ISO 100 film. You should be able to focus in any light in which you can successfully handhold your camera and in even lower light levels, too. (The lowest recommended shutter speed for handholding is about 1/30 second.)

Contrast is the other quality of light materially affecting autofocus operation. With autofocus SLRs, the visible light reflected from the chosen subject must include sufficient contrast to allow the autofocus system to discriminate between different levels of contrast in the subject. Autofocus SLRs use differences in contrast between adjacent parts of a subject to determine an exact point of accurate focus. Sufficient contrast—dark and light portions in the same subject—must exist so the focusing system can sense differences electronically for comparison. It can then lock onto something and move the lens to its correct focus. If the subject is a smooth, featureless, brightly lit wall, virtually no autofocus SLR will find it easy to locate and lock onto the subject in the autofocus rectangle and move to a point on its surface. And under dim, heavy overcast conditions, the AF systems' problems are made even more difficult. When faced with a low-contrast uniform surface, the camera will hunt back and forth, unable to find a point to focus on.

Each autofocus system has differing contrast requirements to work properly, so I recommend you try each system on subjects you shoot regularly before selecting a camera. More recent autofocus designs have markedly improved both their low-light and minimum-contrast performance. If your eye can see detail in the subject clearly from about six feet, then almost any autofocus SLR should be able to focus it accurately.

Low-light and low-contrast levels have one more negative effect on autofocus operation: they tend to slow it down. I have found autofocusing to be noticeably slower in dim light than in bright light. However, all focusing systems, including our own eyes, tend to slow down and become less discriminating as light levels drop.

You can probably think of many past situations in which focusing speed was an important part of getting a particular picture. On the average, autofocus cameras can deliver *accurate* and *consistent* focus significantly faster than cameras that focus manually. When all other factors are constant, tests of focusing speed confirm this. Many photographers have learned to focus very rapidly; 2.5 seconds is the average focusing time. All but a few specialized lenses on AF Compacts or SLRs can be focused in one second or less. Autofocus has a definite advantage when it comes to the combination of speed and accuracy.

Does autofocus work as rapidly as it needs to in every picture-taking situation? No! There are situations (discussed in later sections of this book) that are, as of this writing, beyond the capabilities of contemporary autofocus cameras. However, the very same conditions that defeat autofocus will create problems for the manual-focusing photographer, too.

THE CREATIVE POTENTIAL

All the things we've considered about autofocus up to this point only make taking a picture easier. Does autofocus foster creative expression as well?

To begin to answer this question, consider that with autofocus one can

Sometimes architectural detail and pattern are more interesting than a structure taken in its entirety. Here the repeating shapes of the brightly colored slate roofs create a wonderful rhythm.

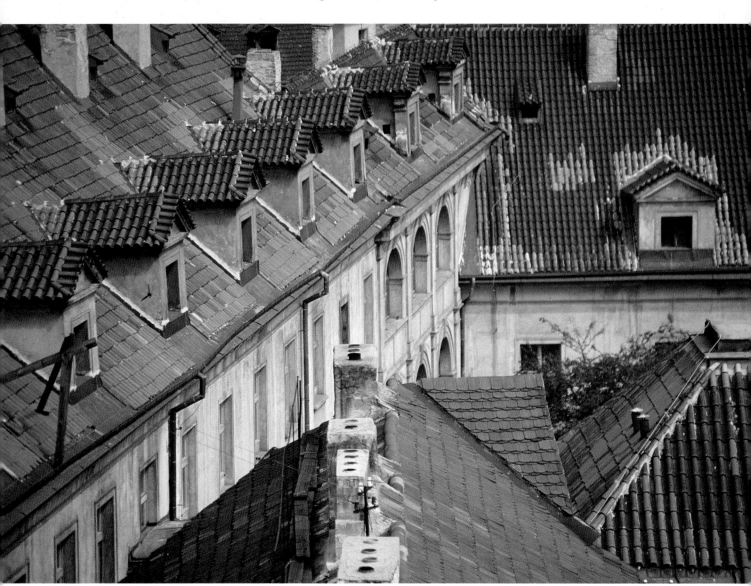

eliminate the nasty habit a lot of us have of always fiddling and fussing with focus. This tends to be a distraction from the real business at hand—trying to figure out what we want our photograph to say about the scene before us.

Most focusing aids in conventional cameras are found smack in the center of the viewfinder screen. In many manually focusing SLRs, these aids can be visually complex because they are composed of microprisms, diagonal or horizontal split-image rangefinder lines, and other devices. Even though the autofocus detector rectangle in autofocus cameras is located in the same place, it presents a much less cluttered view to the user, because it is composed of only a few small etched lines on an otherwise clear screen.

At times, especially in difficult or critical focusing situations, I've found myself totally absorbed in the focusing process with no thought of principal subject matter, let alone corners and edges. The natural rhythm of looking at subjects has been disturbed because I was forced to shift my attention to a mechanical task. Although other photographers claim they can focus, edit, and compose simultaneously, I can't. I suspect that's true of most photographers. Even when we develop skill at focusing conventional cameras, emphasis is invariably on the very center of the image, often at the expense of content in other parts of the scene.

Although I spent the better part of twenty years working out an efficient method of photography, I had to reexamine my entire approach after using an autofocus camera. I found myself studying edges and corners more, finding content there that I hadn't noticed before. I also began to recognize what I was after more quickly. The more accustomed I became to autofocus and the more I grew to trust it, the more spontaneous this creative cycle became.

Photomicrography, or photography through the microscope, is a very precise business. As you might imagine, precise focus is essential. Autofocus—principally continuous autofocus—is a very efficient way to ensure critically sharp focus. Crystals offer a fascinating, never-ending variety of subjects. Surprisingly, all you need is a reasonably competent microscope, a simple camera/microscope adapter, some appropriate crystals, and two pieces of polarizing material. I've made hundreds of such abstract images using a children's microscope on my dining room table.

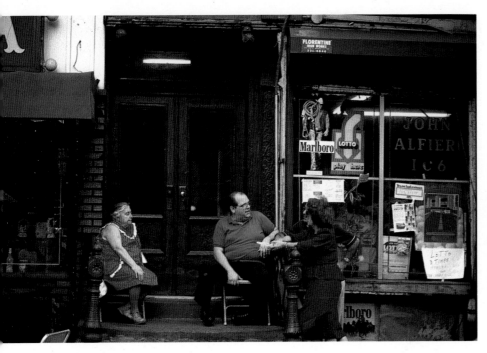

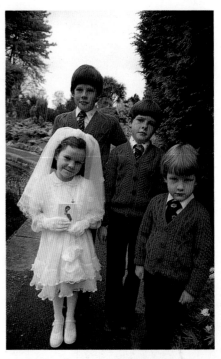

There are an unlimited number of picture-taking environments. I particularly enjoy working the street. This is New York City's Little Italy.

If you allow your autofocus camera to do its thing, you may begin to see differently as well. I think it is possible to become more involved with the subject when one is freed from an overconcentration on the purely mechanical details of picture taking. When, for example, autofocus camera designers were able to clean up and eliminate most of the central focusing aids, thus making viewfinders less cluttered, they created conditions that help us see and understand subjects better. Users of compact cameras will not see much change between conventional and autofocus viewing, but in SLRs the difference can be marked.

Autofocus shortens the list of things to think about before taking a picture and thus allows more time and energy to be devoted to creative considerations. Widespread adoption of autofocus should result in a new generation of image makers who learn the craft somewhat differently than did their predecessors. Such subjects as visual organization and the content and meaning of a subject may well take on added significance even for the occasional picture taker. Pictures that go beyond simple documentation are now within the grasp of the average photographer.

This is not to say there is no need to understand the basic tenets of photography. It is just that automation has made understanding the technical aspects of the craft somewhat less critical. Fully automated autofocus cameras make understanding one's photographic purposes more important than the mechanics of picture taking, particularly for beginners. If you are just starting out in photography, it may be comforting to know that automation can move you to the stage where you can *interpret* what you see with a camera pretty quickly.

Portraiture has many subdivisions—studio, formal location, candid, and even photojournalistic. In the photograph above, I used the only camera I had with me, a simple point-and-shoot compact, to create an informal location portrait. I would rather have used a longer-than-35mm-focal-length lens. Nevertheless, technical merit isn't what makes this kind of photograph; it is the sweet innocence of the little girl, the proud protective stance adopted by her two older brothers, and the all-but-total indifference of her younger sibling.

Still life doesn't need to be limited to the studio. As you can see in the photograph on the opposite page, the red door is the principal visual draw. This points up a problem color photographers have: how to use color in such a way that it doesn't overwhelm everything else.

Night photography poses several problems for autofocus camera users. If you contemplate doing a good deal of night work, you'll need a camera with low shutter speeds, at least down to 1/4 sec. To some extent, super-high-speed color films rated at up to ISO 1600 have decreased the need for really slow shutter speeds.

Finally, autofocus should be a real boon to people who are visually impaired. It's awfully frustrating to be confronted with blurry, indistinct images in a viewfinder. A good autofocus system combined with eyepiece-diopter correction now allows literally thousands of people suffering visual impairment not only to focus correctly but also to view and compose a scene that is once again sharp and detailed. Wonderfully imaginative photographs are being taken by people whose eyesight is so bad that they are considered legally blind. Because of autofocus, individuals who were long ago forced to abandon photography can rediscover the joys associated with the craft.

Although autofocus can contribute a new creative approach to photography, in and of itself it cannot guarantee memorable or even interesting pictures—only sharply focused ones. Autofocus can be very seductive, because the temptation is to assume that technical sophistication will automatically lead to a high degree of creative expression. Bear in mind that there are differences between technical sophistication and creative expression, even

though they are often confused with one another. It is because modern automatic cameras deliver astonishingly high technical quality from vastly improved film types that people confuse technical wizardry with creativity. They mistakenly come to believe that a technically correct picture is creative and expressive as well.

Technical innovation only supports creativity. It doesn't replace it. The trick for those of us interested in the expressive potential of photography is to understand what our chosen camera-lens-film combination can and cannot do and then to work out a shooting plan within this framework.

Autofocus allows me to shoot quickly and confidently, and that's essential when I'm grabbing fleeting expressions. The more I can concentrate on the subject without worrying about mechanics, the more satisfying my picture taking is.

WHAT AUTOFOCUS CANNOT DO

Beyond the possible tradeoffs that we take into account when using automated still cameras, autofocus has a down side. Autofocus systems in practically all compact autofocus cameras are usually designed not to focus on a specific point in space but rather within one of a few preset zones. If the subject you intend to photograph falls within the camera-selected zone and the lens is stopped down by the automatic, programmed metering system to provide adequate depth of field, your subject should be rendered in adequately sharp focus. But if not, the result will be a fuzzy, out-of-focus image.

Most medium-priced compact autofocus cameras offer the user eight to eleven zones at most; a few of the best offer sixteen to thirty-five. For better focusing accuracy, the more zones the better. Best of all would be a zoneless system. Although it is possible to design an infinitely focusing autofocus system based on infrared-reflection technology, only a few camera makers have chosen this superior—and much more complex and expensive—design option.

The Problem of Subject Movement. Certain types of subject movement present very difficult problems for autofocus cameras, much as they did for their manual-focusing forerunners. Even the most advanced forms of autofocus will be hard pressed to focus correctly on rapidly moving subjects and then refocus fast enough to keep pace with the action. Typical subjects in which this problem is likely to be encountered are quick-moving sports such as ice hockey, basketball, and auto or horse racing. To some extent you can devise certain compensating techniques, such as anticipating peak action or panning to minimize focus lag. Also, it helps to position yourself in such a way that you are not shooting action coming directly at you, for focus lag is particularly acute when shooting rapidly moving subjects coming directly at the camera.

Almost all autofocus SLR focusing relies on sufficient levels of subject contrast (contrasting dark and light areas within the scene) to achieve correct focus. Lacking that, some autofocus systems, especially those found in SLRs, will wander aimlessly back and forth, unable to lock on to only one point. A smooth, featureless, evenly lighted wall usually defeats an SLR autofocus system.

It is not unreasonable to expect one or two unsharp pictures per 36-exposure roll when using a compact autofocus camera. User tests confirm this figure. For SLR users the incidence of poorly focused pictures decreases somewhat. In fact, the technology to minimize or even eliminate both the focusing lag and low-light, low-contrast problems already exists, but it is hard to predict when we will see it in commercial production. With the fast-increasing popularity of autofocus, we can expect design improvements to be incorporated into cameras rather rapidly.

In this informal industrial group portrait, lighting plays the significant role, dramatizing the subjects against a somber background. This picture would be a good opener to a photo piece because it sets the scene.

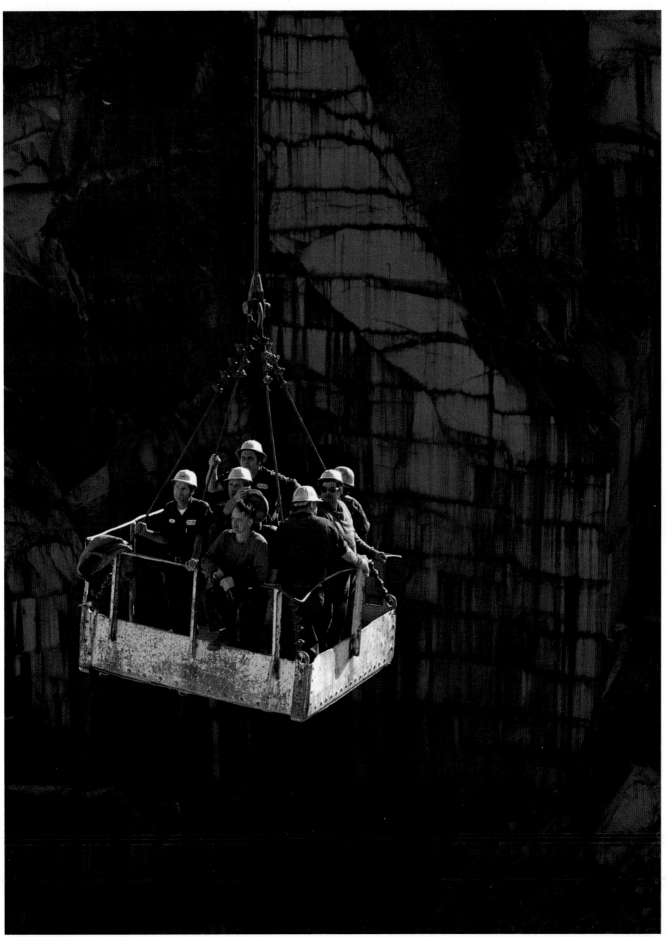

Margaret Williams

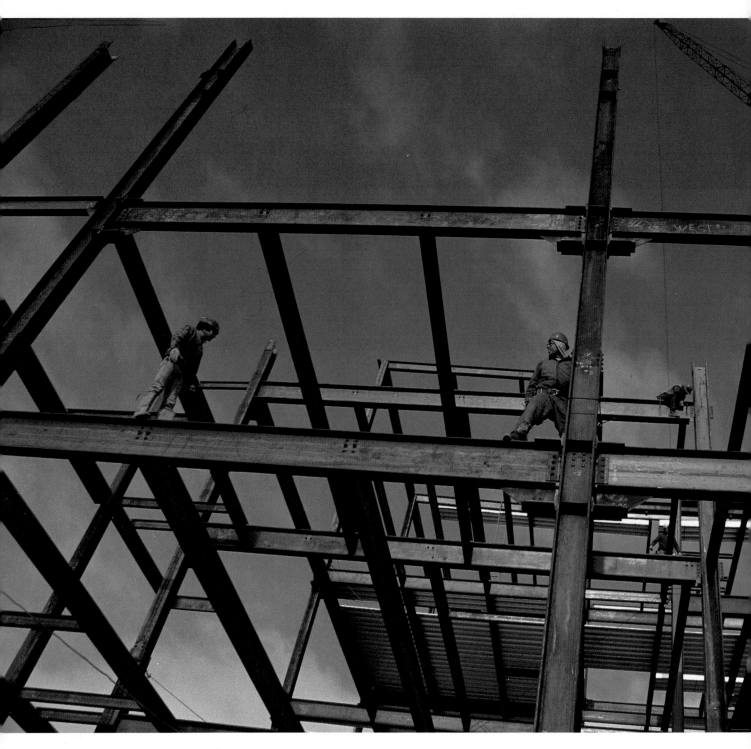

I shot nearly two 36-exposure rolls at this construction site. I selected this one to represent the high ironworkers, because while the two figures in the foreground appear to be relatively insignificant physically, they are very dominant psychologically.

Other Limitations. Compact and SLR autofocus cameras have somewhat different limitations. There are some hard-to-focus subjects for both compact and SLR autofocus systems. Compacts have difficulty focusing black objects like hair, wire netting, latticework, or cage bars. Additionally, flickering light sources such as neon, fluorescent, TV images, or even sunlight coming through trees can confuse infrared autofocus cameras. Likewise, other brightly reflective subjects, such as water surfaces, mirrors, or shiny car bodies present difficulties. But it is windows that confound autofocus the most. Almost all active infrared focusing cameras want to focus on the window and not the scene on the other side. After all, the focusing system has no

way of knowing the glass is not the intended subject. Another limitation of current infrared systems is one of the design and not infrared per se. Zone focusing found in most compacts is inherently less accurate than direct subject focusing.

While autofocus SLRs do have some of the very same problem subjects as compacts, they also present the user with a few additional difficulties. First of all, latticework, grilles, or cage bars are difficult for comparison-contrast auto-focus in SLRs. Not unlike infrared, autofocus SLRs tend to focus on the grilles or bars rather than what is behind them. But unlike compacts, autofocus SLRs do quite well shooting through window glass, water, and car bodies, provided there is sufficient contrast within the subject under the focusing rectangle in the viewfinder. How much contrast difference is needed for an autofocus SLR focusing system to operate varies from model to model. Another principal difference between the infrared system found in compacts and the contrast-comparison in SLRs is that infrared has no low-light-level limit and can be made to operate in complete darkness. On the other hand, all contrast-comparison types need a minimum level of visible light to oper-ate efficiently. The minimum level needed varies from camera to camera. To date, the lowest light threshold claimed by any autofocus SLR camera is about EV 1, equivalent to a light reading of f/5.6 at 1/8 sec. using ISO 100 film. Finally, several autofocus SLRs have either built-in or supplemental infrared flash systems that are used to aid the main focusing devices. Some cameras even use infrared without flash to extend the low-light-level limits of auto-focus SLR focusing.

A PERIOD OF READJUSTMENT

The final autofocus liability we need to consider here is our own natural resistance to new and different ways of doing things. For individuals just starting out in photography there is no problem, for they've probably never experienced picture taking without autofocus. But for those of us who were weaned on manual focusing and hand-set exposure, converting our thinking and coming to trust automation—especially autofocus—takes time. It took me a good eight months of extensive use to "grow into" my present autofocus camera.

The situation is not unlike that of automobile enthusiasts who for one reason or another are forced to give up their cherished five-speed manual transmission for an automatic. In their heart of hearts they are convinced that driving with an automatic isn't really driving at all. For that kind of person, the only possible salvation might be a *shiftable automatic*, but for a majority of us, automatic will do just fine.

Although current autofocus cameras do have their limitations, they accom-plish their task extremely well. They allow users to devote more effort to finding creative solutions to photography problems. It's actually possible to get pictures that were previously lost, because the autofocus system enables one to react and take pictures faster. Also, consider that employing autofocus-coupled flash in extremely low light that is below the accurate manual-focusing threshold allows autofocus camera users to shoot away happily.

When the great photographer Ernst Haas talked about the key to mean-ingful picture taking, he spoke of the difference between seeing and orienting one's self. Seeing involved a full awareness of the subject, orienting only a vague sense of some subject qualities. In Haas's terms, autofocus can contrib-ute to a fuller awareness for both amateurs and professionals.

2 EVALUATING THE CAMERAS

Macro shots like the one on the opposite page demand precise focusing, careful attention to design details, and the operational flexibility only an SLR affords the user.

Often all the elements of a photograph come together at one time. Dave Mengle's study in the photograph below, is an example of what can happen when the photographer is patient and waits for the right moment.

After much speculation and nearly ten years of false starts, the first usable autofocus camera was introduced to the buying public in the fall of 1977. For all practical purposes, the Konica C35AF—a simple, well-proven design to which an autofocus module and associated circuitry were added—marks the beginning of the autofocus revolution in still photography. Since this modest beginning in 1977, the relatively small, light, and simple-to-operate autofocus lens/shutter compact 35mm camera has come to dominate the camera marketplace to a point where it is now outselling all other cameras including nonautofocus single-lens reflex cameras worldwide.

It seems that snapshooters are not the only ones who find these little do-everything marvels irresistible; advanced amateurs and even professionals can be seen pulling autofocus cameras from their coat pockets and shooting away. Why? Because what auto-everything compacts have going for them is the fact that users need not concern themselves with the process at all, only

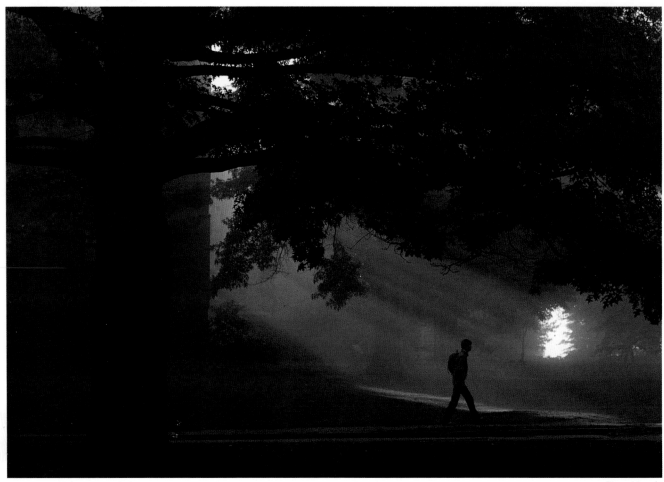

Dave Mengle

Dave Mengle

with the result. Just two decisions are of importance to users of these cameras: what to shoot and when. Industry researchers told manufacturers that was precisely what the new generation of consumers was looking for, and it seems they were right on the money.

With ever increasing sales of compacts and declining single-lens-reflex (SLR) sales, it appeared that the 35mm SLR was in big trouble. But then in 1984, the Minolta Corporation stood the camera world on its collective ear with the announcement of an advanced autofocus 35mm SLR with a complete, integrated system of accessories. The Minolta Maxxum, the first really practical autofocus SLR, was a marketing masterstroke. Other camera makers rushed to introduce their own 35mm autofocus SLR systems in order to share in the enormous sales success of the Maxxum. Some analysts predict that soon four of every five cameras sold worldwide will be autofocus, with hi-tech autofocus SLRs taking an ever increasing share of the sales.

AVAILABLE OPTIONS

As might be expected, autofocus (AF) technology has branched out in new directions as photographers' demands for specific features have made their way back to corporate headquarters. The result: at least six separate design philosophies representing sometimes distinct, and sometimes overlapping, segments of the camera market. Let's take a look at current autofocus options, from the simplest and least expensive to the very sophisticated and generally most expensive.

Simple Point-and-Shoot 35mm Compact. These cameras automate everything from film loading to rewinding. The only decisions left to the user are what to shoot and when to shoot it. This type of autofocus camera seems just right for occasional users who want better image quality and more convenience than camera types smaller than 35mm—disc cameras, for example—can provide.

Typical of the high-quality do-everything compact autofocus camera is this model from Minolta.

Courtesy of Minolta Corp.

Advanced Point-and-Shoot 35mm Compact. These cameras, of which there are many on the market, are designed for photographers who take more pictures than the occasional snapshooter but still demand no-fuss picture taking. These people are willing to pay more to get higher-quality images.

Dual-Lens Compact. Seen in increasing numbers are the compact autofocus cameras featuring convertible or dual lenses that can be switched from a now standard 35–38mm wide-angle optic to a longer telephoto 60–70mm lens. With this longer focal length in place, photographers are able to shoot more pleasing portraits by minimizing the apparent wide-angle distortion at close range. This dual-lens magic is accomplished by incorporating a tele-converter unit behind the main lens, thus increasing its effective focal length. In most dual-lens compacts, this conversion takes place at the press of a button. However, a few require that you manually twist the lens barrel to change focal length.

Using a teleconverter to achieve a longer focal length does require some compromises. First, there is an inevitable loss in sharpness, but it appears to be minimal in terms of practical picture taking. Second, shifting a teleconverter into position decreases all shooting apertures by about 1½ stops (for example, an F3.5 lens becomes F5.6). How well does the new smaller maximum *f*-stop lens do at autofocusing? Quite well from the images I've seen taken with these cameras.

Because designers have increased the number of focusing zones to as many as twenty, the possible gaps created by the telephoto lens's shallower depth of field does not appear to be a significant problem. Also, the telephoto's smaller apertures provide some additional depth of field to further fill potential focusing gaps.

Zoom-Lens Compact. To date, the ultimate development of the compact autofocus concept is the zoom-lens compact autofocus. True zoom-lens compacts can be zoomed continuously, which is different from simply switching between two focal lengths as in dual-lens cameras. Thus a 35–70mm zoom-lens camera provides the user with thirty-six separate focal lengths, giving you the freedom to compose and edit in the viewfinder in a way not possible with single-focal-length or dual-lens compact cameras. Further, zoom-lens design allows focusing closer than two feet from the subject.

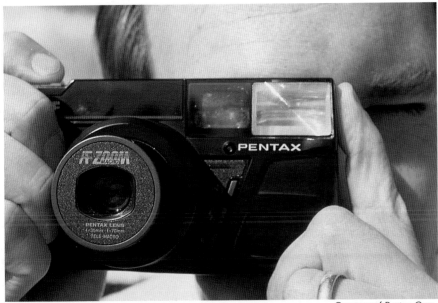

Courtesy of Pentax Corp.

Slightly heavier and bigger than other compacts, the zoom-lens autofocus compact offers the most operational flexibility of all non-SLR autofocus cameras at a competitive price.

A few zoom-lens compacts contain integrated zoom finders coupled to the lens. As the lens zooms in or out, so does the finder. In this way, the viewfinder shows the size of the subject at any particular focal length. Additionally, zoom compact cameras have replaced the mechanical spring-tension lens-positioning arrangement, commonly found in compacts, with a much more precise and reliable electronic stepping motor. This is a particularly important innovation since some of these zooms offer quite close focusing where depth of field is strictly limited and lens placement becomes the critical factor.

35mm SLR. The camera designs available in this category vary greatly. All attempt in one way or another to blend the operating ease of automated film loading, autoexposure, and autofocus with the inherent flexibility of SLRs. Their versatility is enhanced by the availability of numerous interchangeable lenses and many other system accessories. These cameras are potent picture-taking instruments and are gaining in popularity among those who have long wanted to become more serious about their photography but were previously put off by the technical complexity of conventional-quality cameras and among committed photographers who find that autofocus SLRs open new creative possibilities.

Professional-Caliber 35mm SLR. These cameras move autofocus to the top of the quality ladder. Designed to withstand heavy use day after day, they feature numerous exposure options, very fast motor drives, and other exclusive operational features. While they are probably more camera than the casual shooter will ever need—and very expensive—the fact that they can be operated as fully automatic point-and-shoot picture takers has resulted in many sales to nonprofessional and even neophyte picture takers.

An abstraction, in its most fundamental form, is something that symbolizes something else. What I saw here was a distinctly oriental motif and not what those who are more literal-minded saw—just the side of a rusting car.

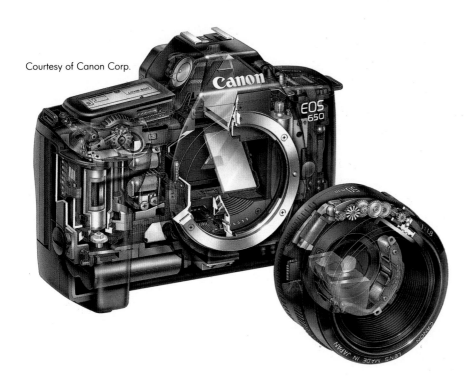

Courtesy of Canon Corp.

These skeleton views illustrate the design philosophies behind two different high-quality autofocus SLRs. Canon chose to incorporate an autofocus mechanism into each individual lens, while Minolta's pioneering Maxxum system houses the autofocus motor and associated gearing in the camera body.

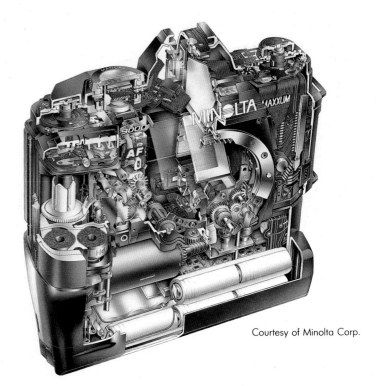

Courtesy of Minolta Corp.

COMPARISON OF AUTOFOCUS CAMERA TYPES

Camera Type	Key Features	Advantages	Disadvantages	Intended User
Simple point-and-shoot compact 35mm	Small, light Totally automatic	Better-quality pictures than smaller film formats Little photo knowledge necessary to operate	Not a very flexible picture taker Limited flash range Limited shutter speeds	Occasional users For "record" shots—birthdays, vacations, Christmas, etc.
Advanced point-and-shoot compact 35mm	As above, plus some are waterproof Some offer a few more features (options such as continuous motor film advance and fill flash)	Good-quality lenses May allow some exposure compensation	Limited flash range Most don't focus closely Usually no provisions for filters Batteries are expensive	Those interested in better-quality images than possible with simple cameras More advanced photographers who want a quick back-up camera
Dual-lens compact 35mm	Choice of wide-angle or short semi-telephoto lenses Fill flash Some with close-up capability Backlight compensation	More flexible than 1 and 2 above With some, tight head-and-shoulder portraits possible Reasonable size and weight for features offered	At the size limit for pocket cameras Slow telephoto lenses Relatively expensive Limited slow-shutter speeds	Photographers who like automation but also desire creative options of dual lens
Zoom-lens compact 35mm	Wide-angle, short telephoto lens True zoom with close focusing, motorized zooming Multifunction flash	Most feature-laden compact. Relatively powerful flash Versatile picture taker	Almost as expensive as low-priced SLRs Heavy for a compact	For quality-conscious picture takers who want automation but also potential of a zoom (may have professional applications)
Autofocus 35mm SLR	Wide range of lenses and accessories Thru-the-lens metering, viewing, and focusing Fast, motorized film advance Precise, rapid autofocusing	Operational flexibility Usable under wider range of light conditions Powerful flash available Sophisticated electronic accessories	Older lenses of same brand may not work More expensive than manual cousins Larger, heavier than compacts	Photographers interested in ease of operation, manual override, wide range of accessories Some professional interest
Professional-caliber autofocus 35mm SLR	As above, plus wider range of accessories and operating modes, faster motor drive, other pro features	Often built to withstand rough, heavy treatment Advanced electronic accessories Usually faster autofocus action Can be used as high-quality, fully automatic camera	Most expensive autofocus and most complex features Some knowledge of photography necessary to take full advantage of capabilities Older lenses of the same brand may not work	Advanced amateurs and professionals

COMPARISON SHOPPING

Several features and specifications are worth examining in compact and SLR autofocus cameras in order to separate the standouts from the also-rans. Here are a few of the most noteworthy:

Backlight Compensation. This is a very important control, especially on auto-everything compacts and SLRs. It allows you to increase exposure by 1½ to 2 *f*-stops to compensate for an overly dark main subject that is backlit or extremely sidelit. Without this compensation, the main subject will be under-exposed. Also, many autofocus SLRs offer more refined exposure compensation in the form of an exposure-biasing control. This device allows the user to subtract or add up to five *f*-stops in 1/2 stop increments.

Daylight Fill Flash. This control is either automatic or user-selectable and is meant to provide enough flash to fill harsh shadows or prevent underexposure of the main subject because of strong backlight. You will find the best arrangements to be those that balance natural light and flash in such a way that the flash effect is subtle and all but undetectable.

I was attracted to the timeless quality of this scene that doesn't exist any more. Some people think parking lots are more important than flowers. Note how the composition leads your eye from the front to the rear. This picture was made using the wide-angle lens on an auto-focus compact.

Wild and unpredictable things happen when color is set in motion. I shot this carousel at 1/8 sec. To manipulate a scene in this way you need a camera that has user-adjustable controls.

My eye was attracted to the graphic quality of this subject. I used a polarizer over the lens to increase color saturation, and overrode the camera's programmed exposure recommendation, selecting ƒ/16 to maximize depth of field.

Close-Focusing Capability. This feature is especially important for compact users. There is a surprising difference in image size between pictures taken at the normal closest-focusing distance of most compacts, 3 to 4 feet, and the closer-than-normal 2 to 2.5 feet offered by some compacts. At 2.5 feet, for example, compacts will deliver nice tight head-and-shoulders portraits, while at 4 feet the best they can do is an unspectacular below-the-waist to top-of-the-head shot. The latter situation can be particularly irritating if you are interested in portraits. Autofocus SLR close-focusing is not nearly the problem—first, because most SLR lenses focus far closer than their compact cousins and, second, because a vast array of lenses is available, some allowing focusing as close as lifesize.

Correct-Focus Confirmation. Virtually all autofocus cameras will confirm correct focus. While most autofocus cameras give a visual signal, a growing number cheerfully beep out a confirmation. I like audible signals, especially those that can be turned on and off.

Chandra Swami, M.D.

Deliberate underexposure of relatively high-contrast Kodachrome 64 resulted in this stunning, lush color landscape. Sometimes film choice makes all the difference.

FRONT-OF-THE-LENS ACCESSORIES

Very few compact autofocus cameras are threaded for filters or other screw-in lens accessories. On the other hand, all SLR lenses can be fitted with filters or accessories. Front lens attachments probably aren't too important for the simple point-and-shoot camera user, but the more serious user might find it hard to be without a filter capability.

User-Changeable Batteries. A good number of first-generation autofocus compacts and even a few current models are powered by lithium batteries that cannot be user changed. Instead, the camera must be sent to an authorized repair station or the manufacturer. This does not make sense. A friend of mine tells a story about the time the factory-installed batteries in his camera died the day before he was scheduled to leave on an extended vacation. He had no choice but to go on his trip without his favorite camera.

Battery-Check Facility. All autofocus cameras are totally dependent on battery power, so it is essential that you have some means of monitoring battery condition. Most, *but not all*, autofocus cameras make some provision for user confirmation of battery condition. Be sure to check often!

Continuous Motorized Film Advance. The majority of compact cameras advance film one shot at a time, but some feature continuous film advance at about one frame per second. This, while not very rapid by SLR standards, will still allow you to follow a lot of action, shooting at will. Autofocus SLRs all offer some form of motorized film advance, either integrated in the camera or as an accessory. Most have a built-in motorized winder operating at rates of between 1 and 3.5 frames per second. After mastering the technique, panning an action scene while using a motorized film advance can help you create some very striking images.

Limited-Area, or Spot, Meters. A high percentage of autofocus camera meters read the entire scene you see in the viewfinder and average the light values, translating them into a program value representing a specific f-stop/shutter-speed combination.

This arrangement works quite well in many picture-taking situations, but not all by any means. Narrow-angle spot metering works better in some situations, especially where subjects are back- or spotlit. In my experience, spot or limited-area metering is more precise than full-area metering, although it's not as fast or easy to use. If you are a more deliberate photographer, limited-area metering might be for you.

At least one school of communication holds that viewers shouldn't be given all the visual evidence available, only enough to engage their curiosity, motivating them to complete the picture. Sometimes it is gratifying to design a picture, stand back, and watch the reaction. It is not always important that the viewer know how it was done.

THE COST-BENEFIT TRADE-OFF

As with all things photographic, using autofocus cameras means making trade-offs. Finding just the right camera can be a frustrating experience. Having searched for the perfect camera for over twenty years, I bear witness to the undeniable fact that there is no such thing as the perfect picture-taking instrument.

While an auto-everything autofocus compact or even SLR might seem ideal, it is still the product of a series of design and economic compromises. The simplicity of automation is both a strength and a weakness. Auto-everything cameras are undeniably quick in operation and reduce photography to its lowest common denominator, point and shoot. However, for many the point-and-shoot procedure is not sufficiently satisfying. While they definitely want ease of operation, they also desire some measure of control over exposure as well as a degree of lens versatility.

No matter what autofocus model you currently use, you'll get better pictures if you take some time to fully understand the capabilities of your particular camera. Ask lots of questions—camera-store personnel are usually excellent sources of information. Talk with friends who know about photography; show them your pictures and ask for their critique. Finally, make sure you understand your camera's instructions. Many problems can be avoided with just a few minutes of reading.

Here are examples of how you can look at the same subject very differently. With a normal or semi-wide-angle lens used five or six feet from the old car, the subject is pictured as a whole. Moving into macro range you are able to pick out sharply defined detail and study it closely. Which picture is more representative of the actual visual experience is a matter of personal judgment.

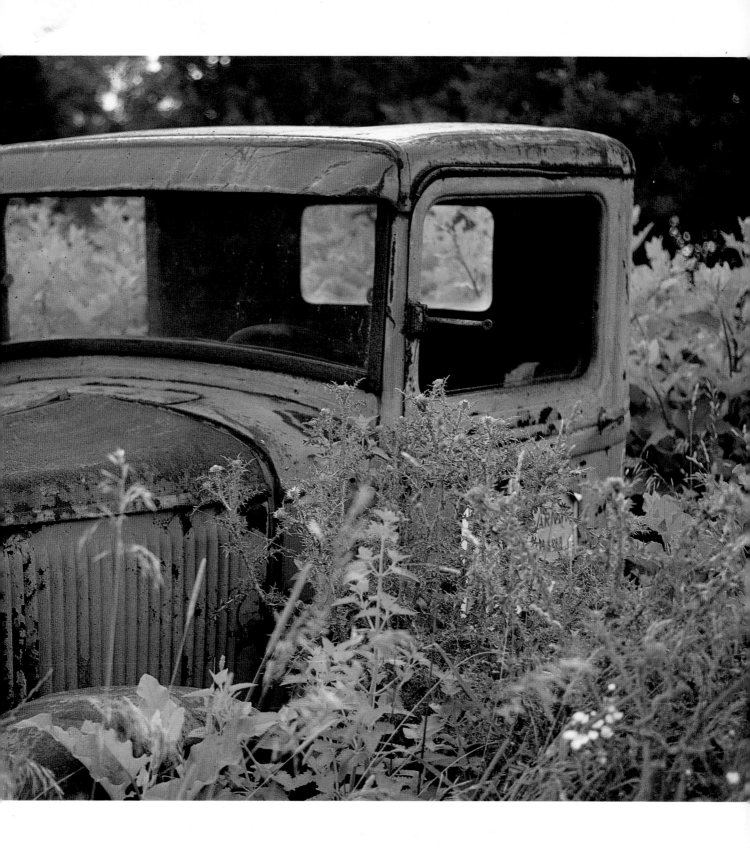

TYPES OF AUTOFOCUS

With very few exceptions, compact autofocus cameras utilize an active infrared focusing arrangement. To activate the focusing system, you superimpose the focusing frame over the principal subject and press the shutter release part way down. As you do, an invisible beam of infrared light is directed outward from a window on the camera face to be reflected off your chosen subject. The returning infrared beam is received by an electronic sensor or array of sensors located behind a second window.

Film-to-subject distance is calculated electronically by a type of triangulation using the angle of reflection of the returning infrared beam. In most contemporary cameras, focusing information is held in memory as long as pressure is applied to the shutter release. This is done to allow both focus and exposure to be frozen in case the user wishes to recompose or photograph a subject that was off center. Some cameras use micro motors to

Active autofocus found in autofocus compacts works well when shooting low-illumination subjects. To my eye, this image exemplifies the vast number of simple everyday subjects we often overlook in our attempts to find bigger, more important things to photograph.

Marion Deppen

position the lens, but most use simple spring forces to position the lens to a precomputed zone closest to the subject's actual location. This focusing action takes place when the shutter release is pressed all the way down. Unfortunately, only a few compact cameras focus on the actual subject in the autofocus frame. Instead, most focus on one of a series of predetermined focusing points, hopefully near enough to the actual subject to render it in acceptably sharp focus.

Obviously, the more individual focusing points in your camera's autofocus system, the more likely you are to get consistently good focusing. A camera that boasts thirteen focusing points will, as a rule, deliver a more precisely focused image than one incorporating only five points. The few upper-end compacts featuring stepless autofocus operation will do better still. Under most circumstances, they should prove the most accurate of the autofocus compacts. Stepless autofocus will focus on any point you choose, from the lens's minimum focusing distance all the way to infinity. That means it will focus on an infinite number of points, not just the eight, fifteen, or thirty preselected points found in the more common zone-focusing systems.

This is not to say that acceptably sharp images cannot be made with a stepped autofocus. I think you will find that most autofocus compacts deliver quite sharp pictures even though they focus in steps. This is because compacts come equipped with semi-wide-angle lenses that possess an inherently great depth of field, an optical quality that forgives focusing errors.

Stepped focusing is fine for standard 35–40mm autofocus lenses, but the problem becomes more acute as lens focal length increases, as in dual-lens and zoom-lens compacts. The fact of the matter is that as longer lenses are used on compacts, available depth of field decreases and focusing accuracy becomes more and more critical.

Here we have an example of a picture that's all but perfectly composed. Framing is precise. When you don't have to worry about focusing and other manual manipulations, you are likely to see many subjects you might previously have overlooked.

Bob Baumbach

Autofocus helps make photographs like this a success. In such situations, where you can't control the wind completely, the actual point of sharpest focus shifts constantly. This can drive you crazy if you are manually focusing. Autofocus makes it a simple matter to get precise focus all the time.

SLR Focusing Principles. Autofocus SLRs use forms of a focusing system generally referred to as *phase-detection* autofocus. This is a self-contained passive system that does not require the camera to send out infrared beams. Instead, it uses internal electronics to read subject contrast and then command the lens-focusing micromotor to drive the lens to correct focus. This system follows the same principle as the manual-focus split-image range-finder, in which the focusing ring must be turned until the top and bottom halves of the split-subject image are aligned. The amount a subject is out of focus and the direction to turn the lens are indicated by the positions of the two halves as seen in the viewfinder. In manual operation, as you turn the focusing ring in the proper direction, the two image halves come together, and when they are in perfect alignment, or "in phase," the subject is in focus. Most passive autofocus systems do the same thing, replacing the manual focusing action with electronic signals, microcomputers, micromotors, and associated electronics.

SLR Operating Modes. Focus-priority is meant to ensure sharply focused images each time the shutter button is activated. A picture can be taken only after the autofocus system brings the image into focus. Otherwise the shutter release is locked. I have found this method fine except for the fastest action sequences, because refocusing requires the system to initiate an entirely new sequence of events to focus from subject to subject. This time lag of up to ½ second for each refocusing sequence is enough to hinder our tracking ability with a rapidly moving subject. I've missed several shots because the autofocus system just couldn't keep up with the action. However, I'm not sure I

could have done much better focusing manually. In fact, several experienced photographer friends of mine swear their autofocus cameras do a better job focusing fast-moving action than they ever did manually.

Continuous autofocus is activated and continues to touch up focus as long as the user keeps pressure on the shutter-release button. Like the human eye, continuous autofocus adjusts focus instantaneously even as the photographer moves from subject to subject. Under good lighting, these systems are so sensitive that they respond even to the very slight motions of a flower swaying almost imperceptibly in the breeze. To adjust your focus manually in such situations is an exasperating and time-consuming proposition. Admittedly, out-of-focus shots are possible with any focusing system, but I find that continuous autofocus reduces that problem to a minimum. With practice, this system will permit you to respond to peak action much more rapidly than you can manually or with focus-priority autofocus. All in all, it is very flexible and quite natural in operation.

All autofocus devices work by focusing on a subject in a small rectangle or bracket in the center of the viewfinder. What if the main subject is not in the center? Autofocus designers have anticipated this problem and have built a focus-hold feature into the camera. No matter where the main subject is located in the viewfinder, you need only place the autofocus bracket over it, activate the autofocus system, and either depress the shutter button partially or activate a separate focus-lock control to freeze focus while you then recompose and complete exposure.

Sometimes it's necessary to focus, meter, and then lock these functions into the camera as you recompose. Most, if not all, autofocus cameras have controls allowing you to freeze exposure readings, focusing, or both.

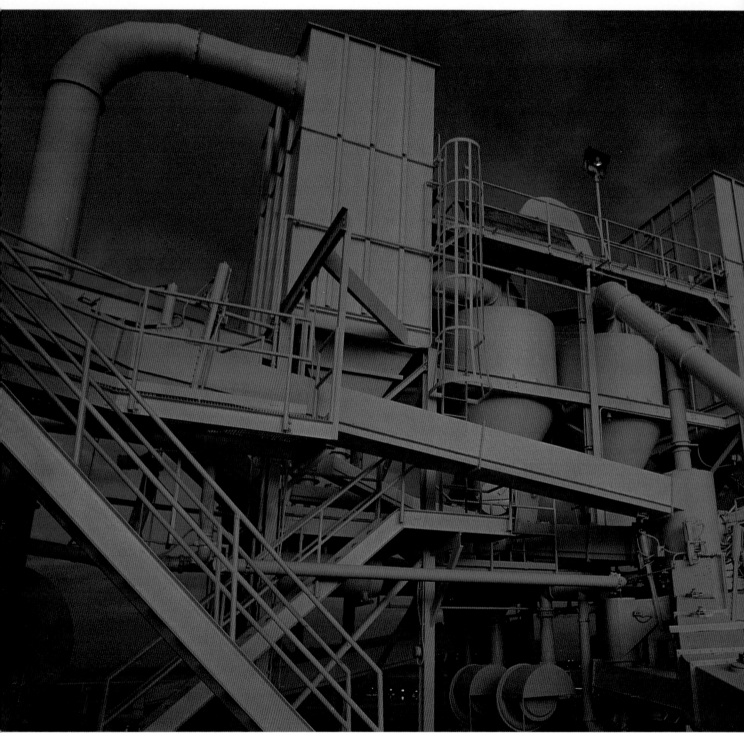

Jason Jones

Some autofocus SLRs have a manual-focusing override. Usually required when subject contrast is very low or lighting is marginal, manual focus works in a conventional manner. Even so, some camera models offer an electronic focus-assist to manual focus, letting you know which way to turn the focusing ring and giving audible and visual confirmation signals when correct focus is achieved.

Recent developments in a number of camera designs have given rise to combination or hybrid systems using phase detection for most focusing chores but offering an active infrared assist for low-contrast/low-light situations beyond the capability of the principal autofocusing system. This arrangement makes it possible to focus in the brightest sunlight or in total darkness, providing the low-light subjects are relatively close to the photographer.

TECHNIQUES FOR
HANDLING YOUR CAMERA

Because autofocus cameras are so easy to operate, it is easy to be careless handling them, but autofocus photography is only as good as the photographer's technique. Bad camera habits will defeat the most refined focusing method, whether conventional or automatic. Here are some tips on how to minimize or prevent camera movement, thus ensuring the sharpest possible pictures.

• Use your body like a tripod with a wide but comfortable stance.

• If you can, use something solid like a tree, a railing, or a corner of a building for bracing yourself.

• Keep your elbows tucked into your sides. Otherwise, they are like the arms of a fulcrum, inducing unwanted movement.

• Press the shutter smoothly and steadily. Never jab at it. Squeeze off a shot the same way you would with a rifle.

Industrial photography doesn't have to be sterile. In fact, a lot of commercial work is quite innovative. Rather than settle for a dull record, photographer Jason Jones, working on assignment, created a strong, visually arresting image by choosing an exaggerated perspective and cleverly manipulating the light with filtration to increase contrast.

PROS AND CONS

It is clear that autofocus has opened quality picture taking to millions of people who would otherwise have settled for barely adequate smaller-than-35mm snapshots. The 35mm autofocus camera has been readily accepted by large numbers of picture takers who are far more interested in the end results than in mastering the techniques of photography. But no matter how clever autofocus cameras become, they cannot create memorable images; they merely record. What electronically enriched autofocus cameras *can* do is free us from tasks that, in my opinion, stand in the way of our seeing photographically.

To date, no one has offered a convincing argument for manual focus being more suited to creativity than autofocus. Both can be directed, monitored, and controlled, but autofocus is faster, more consistent in its results, and in most instances more precise. That autofocus has limitations is very clear to anyone having extensive experience with it. However, as autofocus is refined, more and more individuals will find themselves enjoying these powerful picture-taking tools, capable of turning the images in their minds into real-life pictures.

Overcoming Your Camera's Limitations. To some extent, all autofocus limitations can be overcome. The most common way of dealing with difficult-to-focus subjects, whether you have a compact or an SLR autofocus, is to find a substitute subject that is easier to focus, the substitute being at the same location as your prime target. Simply focus the autofocus system on the substitute, engage the focus-hold control, recompose your image, and then press the shutter the rest of the way to complete the exposure. At least one compact camera maker incorporates an autofocus on-off switch in its most recent models. When the off position is selected, the lens moves to infinity and locks there, allowing you to photograph distant scenics and other subjects through windows.

Some exciting and memorable photographs are very quiet. The snowy fence we see here is one such example. The subject is not the fence per se, but the pattern and form.

I've always liked this picture. It was taken with a simple point-and-shoot autofocus camera like those that millions of neophyte snapshooters use. The image is further evidence that operating simplicity has virtue, for it's a true grab shot taken on the move.

Bob Baumbach

3 ACTION PHOTOGRAPHY

Autofocus cameras are ideally suited for use as fast-acting picture-taking tools. The various autofocus types do not all work equally well, but dual-lens/zoom-lens compacts and autofocus SLRs incorporate performance features that make action, sports, and animal photography a viable proposition for everyone. To make good action pictures requires the three P's: patience, practice, and planning.

Action photography requires a quick response to the ever-changing flow of an event. Only the most proficient and seasoned photographers can keep up with the unfolding action all the time. Most of us are distracted by technical

Powerful diagonal lines on the track and the angle made by the runners poised for the start of the race create visual tension. Strong color against a very dark background further supports the feeling of pent-up energy.

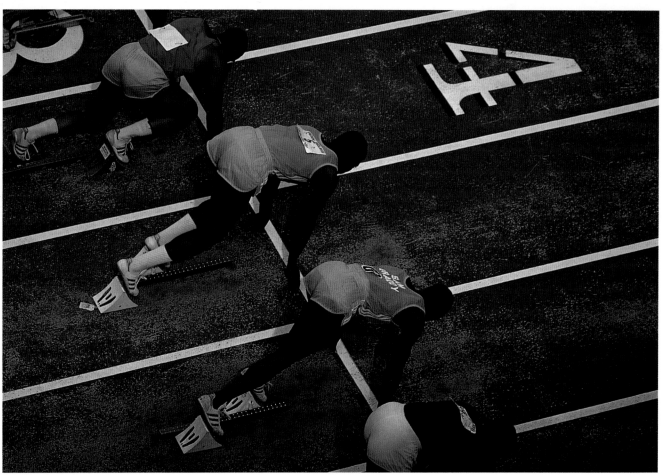

Bob Baumbach

Good timing plays a major role in outstanding sports and action photography. Here timing is everything. An instant earlier or later and the image would have lost much of the dynamic character viewers see in it.

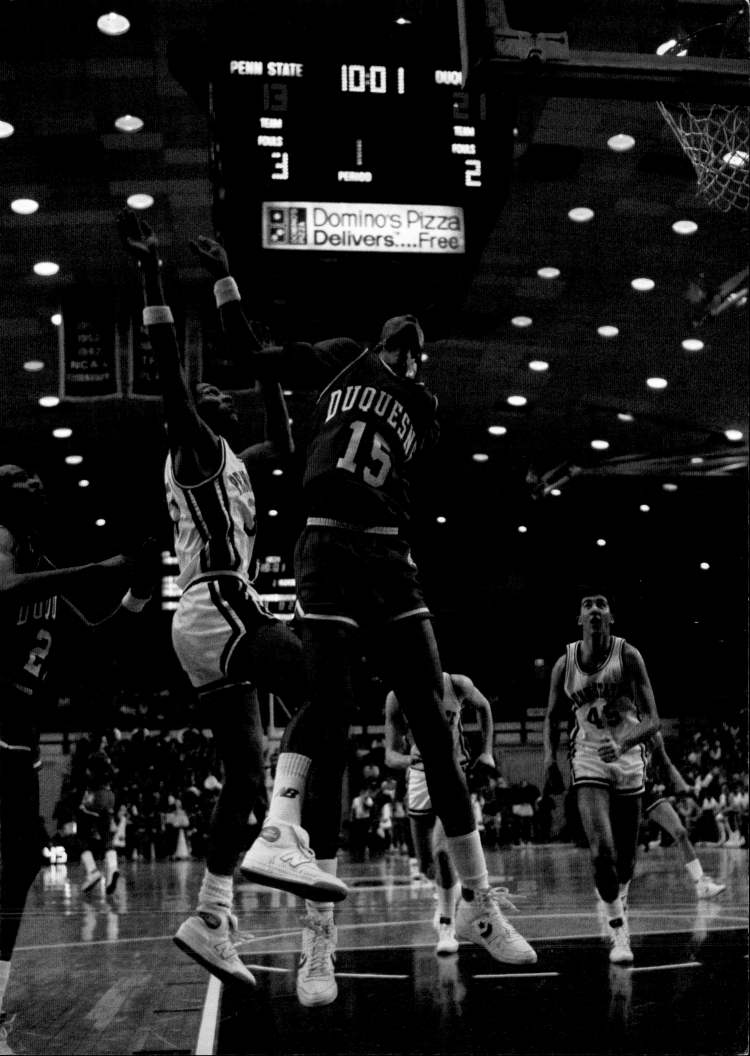

operating details such as metering, film winding, and focusing, although these chores can become second nature. However, most of us have to pause to think about operating details and, if only for an instant, lose concentration on the subject in the viewfinder. When shooting sports or wildlife, such momentary distraction can prove fatal; things happen too quickly. You must be ready to respond instantly—actually before the fact.

Autofocus is not a perfect solution to every difficulty in action photography. Even so, in practical picture-taking situations involving fast-paced action, autofocus has helped me get sports shots I don't think I could have made using my manual-focus camera. I don't think my experience is unique. The same is true for most photographers—even pros.

Let's examine some of the applications of autofocus to the world of action/sports photography.

CAMERA CHOICES AND CAPABILITIES

Point-and-shoot autofocus compacts can be used to good effect if—and this is a big if—you can get close enough to the action to fill the viewfinder with meaningful content, something other than a lot of grassy foreground or

If I were doing a rodeo story, I'd include some detail pictures to give the story immediacy. Getting this kind of picture depends more on the eye of the photographer than on the type of camera used. You can get shots like this with an autofocus compact and the proper ISO film speed for the lighting conditions.

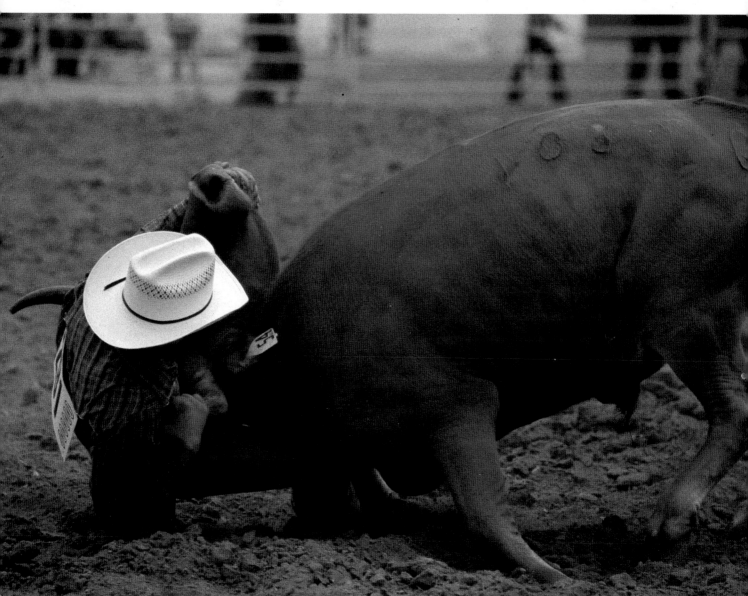

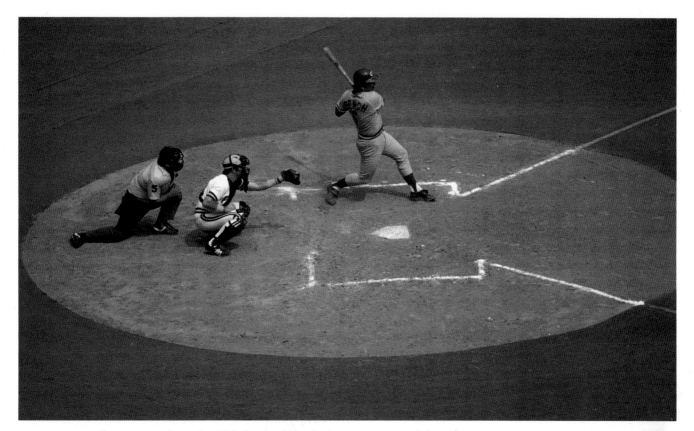

empty areas of water, sand, or sky. This is tough to do because most of these cameras come with semi-wide-angle lenses that focus no closer than three to four feet. They are designed for general snapshot photography of groups of people, buildings, and scenes, and the large size of the intended subject is usually enough to fill the picture frame from normal shooting distances of four to twenty feet. Many times you simply can't get that close to action; you get a picture with tiny figures in a mass of empty space, which is not very dramatic or energetic. Moreover, simple cameras operate with limited top shutter speeds; 1/125 sec. is often the fastest shutter speed available. This doesn't do much to freeze fast-moving action in sharp detail. All is not lost, however. If you can get close to the action, can live with modest top shutter speeds, and can use panning or other action techniques, good sports/action pictures are possible with point-and-shoot autofocus compacts.

Some difficulties posed by sports/action subjects can be partially overcome by using long-focus or telephoto lenses. For our purposes, telephoto is de-fined as a compact autofocus 60mm or longer and an AF SLR with a lens at least 70mm in focal length. Many sports events have sidelines or other physical boundaries limiting access to the action. Even though 60–70mm lenses fitted to many dual or zoom lens compacts do not give you a great deal of magnification, they can help bring in close-to-the-sideline shots not ac-cessible with a wide-angle lens. Telephotos can bring some of the action to you, but they must be used with some thought. First, they magnify both subject and unwanted camera movement. Photographers unaccustomed to telephotos must learn how to hold and use a telephoto-equipped camera properly. Practicing correct technique can minimize image-degrading camera shake. Some form of support (a monopod or tripod is best) helps. Even bracing the camera against a fence railing or leaning against a wall or tree can provide the added steadiness needed to ensure a sharp, blur-free image. If you don't know how to handle a telephoto lens, ask someone you know to demonstrate it for you.

An example of physically inaccessible action brought to the camera by a com-bination of a long telephoto lens and patience. What helped make this picture was my thinking it through in advance. Attempt to picture the image mentally before you even look through the view-finder.

After you have learned how to handle your equipment, you are ready to practice panning your subjects for sharp focus. For those unfamiliar with the term, *panning* is the controlled movement of the camera at the same speed and in the same direction as the movement of the subject. If done smoothly, it produces a sharply defined subject against a blurry background. Remember, the smoother you pan, the better your picture will look. Also, panning too fast or too slow can negate its effect. Panning requires a bit of practice to get right, but it is worth the extra effort in added image sharpness.

Continuous autofocus is the model best suited for capturing action on film because it simulates the working of the human eye. This camera system focuses, then constantly monitors and updates the focus as long as you maintain pressure on the operating button. Continuous autofocus cameras usually have a three-stage shutter release that takes a while to get used to. When you touch the release, both the meter and the autofocus system are activated. If you press a bit harder, both are locked into the camera's electronics and the shutter is released. Finding the exact point at which focusing is frozen or where the shutter is released can be a problem which is solved only with practice. So far, this kind of autofocus system is used only in few high-priced autofocus SLRs, but no doubt it will find its way into more cameras soon.

Waterproof or water-resistant compact autofocus cameras are becoming commonplace. They are great for the beach, sailing, water and snow skiing, fishing, and snowmobiling, to name just a few potential applications. You can get unusual images with all-weather compacts. This is fortunate because most people won't use their conventional, unprotected cameras near water hazards. For people who enjoy water and snow activities, there are also completely waterproof housings for some compact and SLR autofocus cameras, allowing users to do extensive, deep underwater autofocus photography. Some compacts can be taken underwater to limited depths without being enclosed in extra housings.

Jim Collins

Sporting events such as horse races demand techniques such as panning or follow focus to render the subject sharply. Sometimes, even panning and high shutter speeds will not guarantee overall sharpness. In this photo, the slightly blurred hooves add to the feeling of movement.

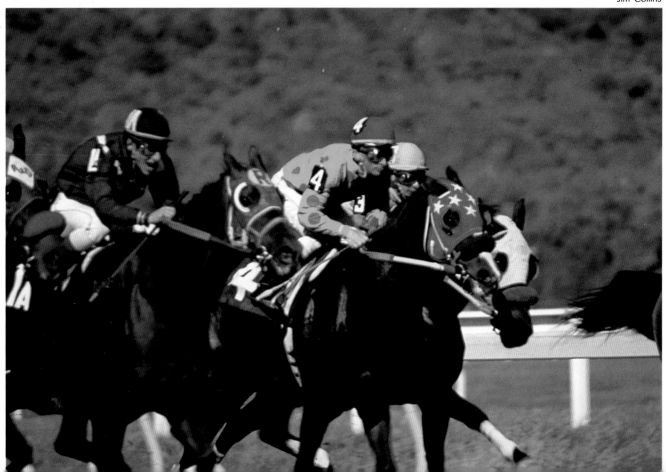

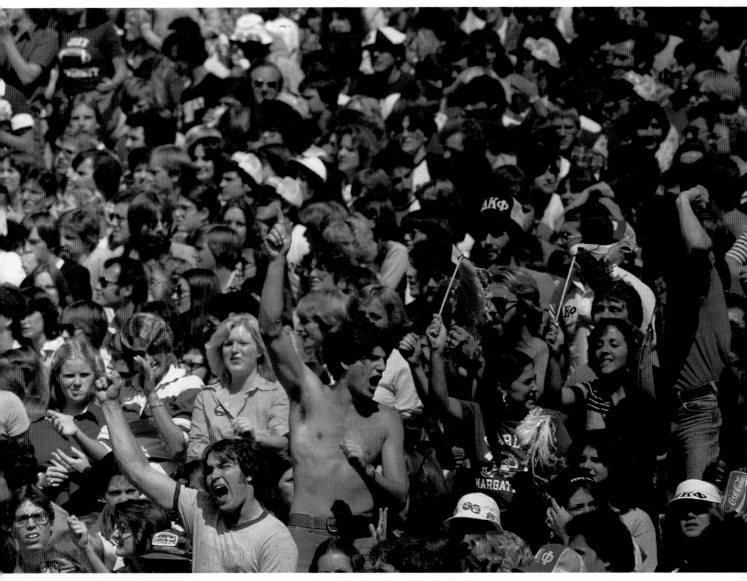

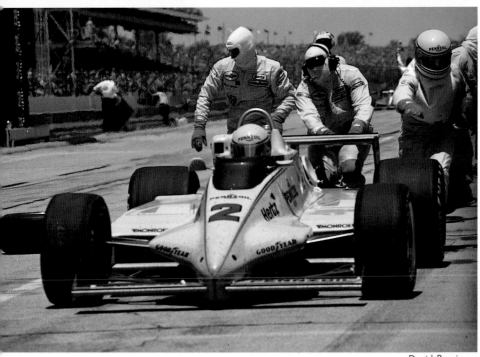

The picture of the crowd could have been made with almost any competent autofocus camera. On the other hand, the shot of the race car, taken from several hundred feet away, was successful largely because of the specialized capabilities of the camera, an autofocus SLR with a 200mm zoom lens.

David Reasinger

FOCUSING TECHNIQUES

Autofocus snaps telephoto lenses in and out of focus very fast, and at the same time the autofocus system is quite selective, because it covers only a relatively narrow angle. These conditions dictate using extreme care when placing the focusing rectangle over the principal subject area in the viewfinder. You must be careful not only to select the proper portion of the picture to focus on but also to keep that area in the focusing rectangle all the time, particularly if it is moving rapidly and your camera employs continuous autofocus. This is easier said than done because when following a moving target with a high-magnification telephoto lens, such as the 200–600mm optics available for autofocus SLRs, the exact point of focus always seems to be moving in and out and up and down. This is even true using short or medium autofocus telephoto lenses (60–135mm), but obviously it is not as severe. You need to learn how to react rapidly and also be precise about shooting technique.

Presetting Focus and Zone Focus. Such sports as football or basketball cover a lot of ground in a hurry. Others are more leisurely—golf, for example. When you are shooting fast-paced sports, you can help autofocus do its job efficiently with a bit of *prefocusing*—bringing the autofocus into the general area of the anticipated action. This will cut down on the adjustment the lens must make to arrive at proper focus. The result is very rapid focus.

By prefocusing on the area of presumed action, such as the line of scrimmage in football on a third-down-and-inches situation, you'll be prepared for nearly instant response to the play. Here is what you do: Find a convenient subject on or very near the spot where you expect the next action to occur. Focus on that spot. Apply finger pressure to the shutter release to freeze your focus (you may also turn off the autofocus system if your camera is so equipped). As the action unfolds—but slightly before the subject reaches the preset point of focus—begin pressing the shutter down to take the picture.

Another good trick to practice is *zone focusing*. Zone focusing requires a camera with adjustable metering. First, determine the area where action is likely. Focus the lens about a third of the way into the area. Using depth-of-field guides on the lens, depth-of-field preview control if your camera has this, or even depth-of-field charts, calculate the f-stop needed to provide adequate depth of field over the entire zone. Set that f-stop. You are now zone focused for the entire area, and anything you photograph in that zone will be adequately sharp. When zone focusing, you can either turn the autofocus off or leave it on. Some of the newer autofocus SLRs have features that automatically allow for zone focusing. *Automatic zone focusing*, also called *trap focusing*, works in the following way: First, the lens is focused to a predetermined spot. The zone or trap focus is then selected by a switch or lever on the camera body. The camera will then automatically fire the instant anything enters the selected zone. Obviously, this operating mode has many interesting applications, such as goal-line plays in football, finish-line track shots, and wildlife shots of bird nests and watering holes.

Poor light and/or low contrast give autofocus systems fits. Autofocus hunts aimlessly under some of these conditions, especially when the subject offers no strong vertical or horizontal line. One way to help the camera autofocus under these conditions is to point it at a bright, higher-contrast substitute target at the same distance as your subject. Focus and then lock or turn off the autofocus. Then you'll only need to recompose and shoot. If you can't find a brighter substitute target, you will need to use manual focus or flash

Anticipation made both of the pictures on the opposite page possible. Zone focusing, or prefocusing, increased the likelihood of success.

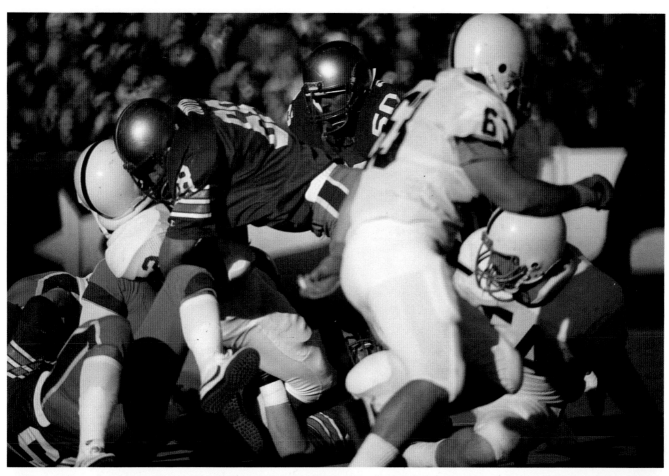

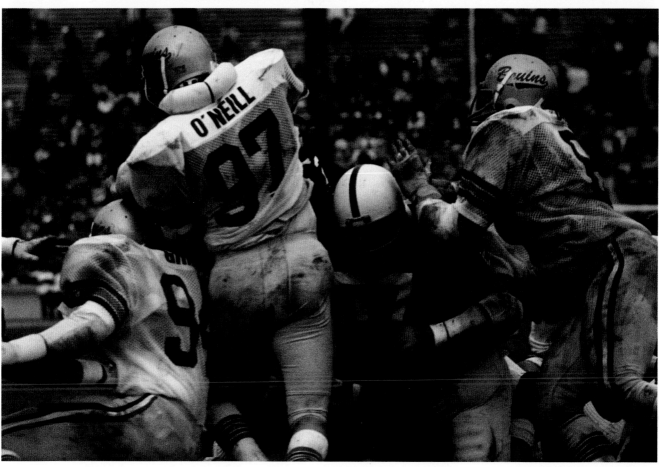

Jason Jones

assist, described below. The infrared systems found in most compacts don't face this problem, but the contrast-comparison systems in autofocus SLRs all do to some extent.

Focusing Assistance from Electronic Flash. Although infrared flash assist is intended primarily for low-light flash photography, it can be used to focus the lens for nonflash pictures as well. This is a somewhat devious way to help autofocus in difficult, low-light situations below the operating level of the main autofocus sensors.

It works like this. Attach the infrared-assisted flash to your autofocus SLR camera. Proceed as you normally would to take a flash picture. In very low light the flash will illuminate the subject with an infrared beam, allowing the camera's electronics to read the correct distance. Under these conditions the lens will operate to achieve correct focus. When you get a correct focus signal, simply switch from autofocus to manual, thus effectively locking the correct focus into the camera. At this point, turn the flash off. You can even meter and adjust composition a bit. Then shoot away.

Just a few cautions. Infrared-assisted flash has a limited maximum range; generally 15 to 30 feet, depending on particular camera model. And the maneuver we're describing will only work with autofocus cameras that can be switched to manual. If you own one, you will be able to focus quickly even in near darkness.

While we are on the subject of flash, you can take advantage of several integrated powerhouse flash units available as accessories for a number of autofocus SLRs and also a few compacts. These units are extremely versatile and can provide accurately metered light on subjects as far away as 100 feet. Almost all of them are dedicated, meaning they are totally integrated into the camera system and work with the camera's electronics to calculate the conditions for each shot by setting the proper f-stop and shutter speed. Further, dedicated flashes allow you automatically to achieve good exposures by combining flash and ambient light. This technique, called *fill flash*, adds just enough flash to the existing light to soften harsh shadows on the subject.

It is easy to see that flash is a great asset in action work when you want to freeze all motion. An additional feature of these high-power, infrared-assisted flash units is their ability automatically to mix flash with available light, especially sunlight, to produce a natural look without the harsh shadows and dark backgrounds usually associated with flash-only pictures. At the same time they permit the use of smaller apertures and will virtually insure needle-sharp handheld images. If you have an autofocus camera with daylight fill-flash capability, I suggest you shoot a roll of film using this feature. You might be pleasantly surprised.

THE PROBLEM OF EXPOSURE

Most autofocus cameras meter automatically, allowing for little if any modification. This is fine if all your subjects reflect an average amount of light, but of course they don't. One easy solution is to custom calibrate your camera's built-in exposure meter, if it is adjustable. To do this, you will need to know what f-stop shutter speed the camera sets. Also, you will need to be able to change the exposure in some way. Point your camera at the back of your hand, making sure that the light falling on it is the same as the light falling on your subject. Note the meter's reading, and if your skin tone is light, add one f-stop to the reading; if your skin tone is dark, subtract one f-stop. If your

In this beautiful study of athletic grace, photographer Jason Jones used flash as the light source. Most autofocus cameras, whether they be compact or SLR, feature varying degrees of flash automation. The most powerful and flexible flashes are found in autofocus SLR systems.

skin tone falls somewhere in the middle, use the reading for the palm of your hand without any addition or subtraction.

Of course, there are wide variations even within skin-tone groups, so it is best to find your skin's + or − factor by comparing an exposure-meter reading from your palm with one taken from a neutral-density gray card, commonly called an 18-percent reflectance card. These are available from any well-stocked camera store. Read the reflected light from the gray card, then from your palm, and note the difference. If there is one, it is your personal compensation factor. Just add or subtract this to the light value from palm-of-the-hand readings and you should get excellent exposure every time.

How about totally automatic cameras? If you have one of these, you cannot affect the metering unless you can lock the exposure reading. (In some compact autofocus cameras, pressing the shutter release halfway down freezes the exposure reading.) First, you'll need a gray card—the palm of your hand won't do. Arrange the gray card to reflect the same light falling on your subject. Point the camera lens at the gray card, press hard, and hold. Hold the shutter release halfway down and maintain pressure, thus freezing the reading. Remove the gray card and recompose, then continue pressing the shutter release the rest of the way to expose your film. This technique allows you to fine-tune your exposure for such tough, high-contrast metering situations as backlit, sidelit, and spotlit subjects.

KEYS TO GOOD SPORTS PICTURES

Basic to all good sports photography is understanding the fundamental dynamics of the event you intend to photograph. You can then anticipate when and where key action will occur and go for the real "meat" of the event—the essence of the sport. Most sports or action-oriented activities feature unique-to-the-event qualities—power, grace, speed, sheer determination, individual effort, and strategy teamwork. The important thing is to find the essential quality and exploit it photographically.

Work Out a Plan of Operation. Planning for sports photography is absolutely essential! It consists of making a series of decisions:

• Select one or more vantage points.

• Choose appropriate equipment (lenses, cameras, filters, and film).

• Consider weather conditions and provide your equipment whatever protection it may need.

Jennifer Tucker

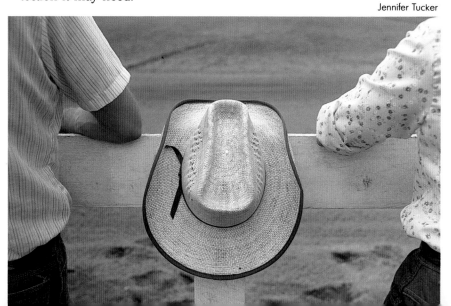

Tightly cropped images of the details of a sporting event provide attractive visual information, but you don't always have to seek out high-powered subject matter. The image of the straw cowboy hats between two onlookers provides an excellent contrast to the violence of the rodeo itself.

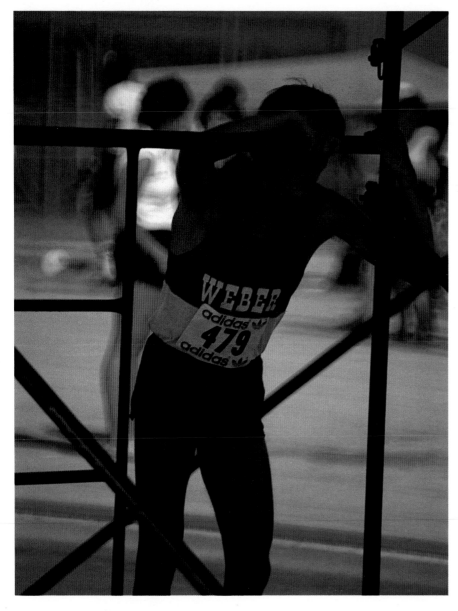

There is a natural tendency to follow the winners, but it's the losers who often provide the richest photo material.

• Check out your selected vantage point before the event and resolve as many potential difficulties as you can.

• Work in mandatory shots, for example: the kickoff, first pitch, horses leaving the gate, color shots of the crowd, cheerleaders, and pregame warm-ups.

• Key in on some of the star players, coaches, and mascots around whom significant action may occur.

Look for Emotion. Pictures that capture emotion have impact. What kinds of emotion can you expect to find in sports? Frustration, anger, anguish, fatigue, exhilaration, tension, suffering and pain, intensity and concentration. Think about what these feelings look like and when and where they're likely to occur. Without emotion, sports images take on a rather flat, documentary appearance. In a sense, emotion is always the subject matter. The vehicle through which it is revealed to the camera is the event.

Look for and anticipate drama. Tension and drama usually increase as an event comes to a close. And keep an eye on the losers. Losers are often far more interesting and animated than winners.

TO12976

Anticipate Possible Low-Light Situations. When the light is poor, there is a trade-off between film speed and quality to take into account. In low-light situations you'll need to switch to fast film to maintain reasonable shutter speeds or even to shoot at all. I generally use the slowest film possible to provide sharp images, but the gritty, grainy quality of some high-speed color films can very effectively underscore certain moods. In some instances you may have no choice. There is an old saying among photojournalists that any picture is better than none at all, and while you may not accept this dictum absolutely, it is not a bad guideline to follow.

Calculate Shutter Time Lag. In action photography, the picture isn't taken when you think it is. Before shooting moving sports subjects with your auto-focus camera, be aware that a time lag of between 150 and 300 milliseconds exists between the moment you begin pressing the shutter release and the point in time when the picture is actually taken. In practice, this means that action subjects will have moved from where they were when you thought you took the picture to a new location some distance away. As an example, a runner moving at 15 miles per hour moves at about nine feet per second.

Peggy White

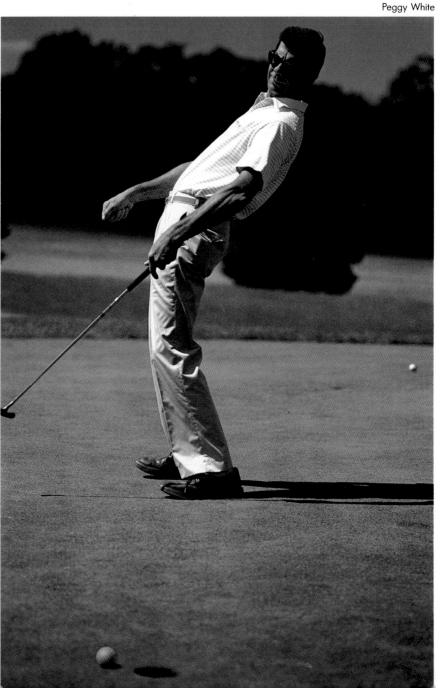

The photographer allowed just enough lead time to capture the subject's expression, posture, and the ball's travel past the hole.

Peggy White

Peggy White's wonderfully inventive image is a kind of self-portrait. Shooting her own cross country skis on the move with a relatively slow shutter speed resulted in a partial blurring of one ski, which underscored the movement. Any of several waterproof or weather-resistant autofocus cameras is suited for this kind of photography.

Figuring the average time lag for modern 35mm cameras, that runner will have moved between 1.3 and 3.5 feet in the time it took to press the shutter and take the picture. This makes a very big difference in how the resulting picture will look. Because many sports/action photographers use telephoto lenses, which have an inherently narrow depth of field, time lag is a very real problem. Quite a few subjects will be sufficiently displaced so that they are beyond the depth of field, particularly at the large apertures often used in conjunction with these lenses.

To counteract this problem, inherent in *all* cameras, it is wise to practice and become proficient at anticipating when and where action will take place and to begin the physical picture-taking sequence slightly ahead of the projected peak action at the point where you anticipate it will occur. It is an admitted compromise to assume where future action will take place, but guessing often works. This technique demands two things from you: (1) lots of practice and (2) some knowledge of the subject to be photographed. After a while you will instinctively allow just the right amount of lead time to locate the subject where you want it in the frame while the picture is being taken. You will need to prefocus carefully and then keep pressure on the shutter release to lock it on your selected spot.

CATCHING THE ACTION WITH PETS AND WILDLIFE

Many of the considerations that apply to sports photography also pertain to animal photography. Since animals are on the move a lot, you need to perfect the same motion-arresting techniques with them as with sports subjects. Remember, autofocus will focus subjects sharply but won't arrest motion.

If a swiftly moving subject should appear in sharp focus, then an appropriately fast shutter speed should be selected. Shooting with an autofocus camera offering user-adjustable shutter speeds helps ensure sharp action shots. If you employ a totally automatic autofocus camera, load it with high-speed film (film with a high ISO number such as 1000 or 1600). You can then hope the camera's automatic exposure program selects a fast enough shutter speed to arrest subject motion. Be aware, however, that the use of such high-speed color film as Kodacolor VR 1000 or Fujicolor Super HR 1600 entails certain compromises. These films are significantly more grainy, produce less saturated color, and generally do not produce as much detail as slower-speed films. You must decide if the trade-offs are reasonable.

The photographer had to do quite a bit of climbing to get within range of this shy subject. But at least once he was within shooting distance, he didn't lose the shot by struggling with the focus.

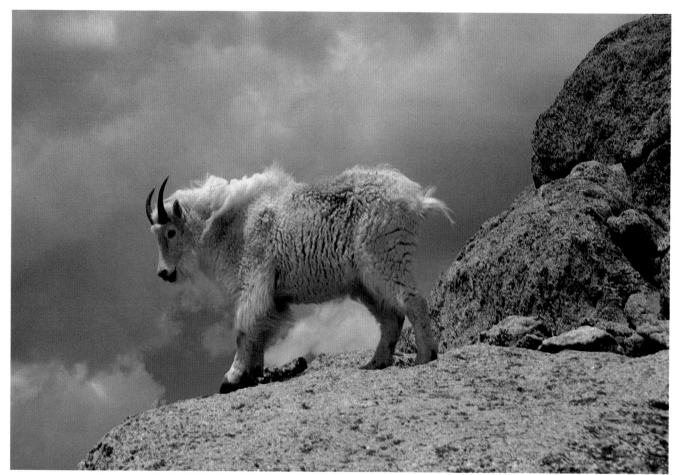

John White

Seen in this light, the porker is almost a silk purse. Lighting contrasts demanded that I pay careful attention to metering. The narrow-angle spot meter in my autofocus SLR allowed me to meter only a small, select portion of the subject to get the effect I wanted.

Tripods—the Animal Photographer's Best Friend. Test after test proves conclusively that, regardless of shutter speed used, pictures taken on a tripod are visibly sharper than those taken handheld. I strongly suggest you purchase a tripod as one of your first accessories. Select one that gets you down low so you can take closeups of insects or other subjects close to the ground.

An added benefit of using a camera mounted on a tripod is that the combination accommodates much slower shutter speeds than are possible with the steadiest hand-held tripod camera. Shooting at slow shutter speeds means you can use sharper, finer-grain film for added detail and smaller apertures for added depth of field.

Lens Choice. Top-quality wildlife photography generally calls for using telephoto lenses of at least 200–300mm, often longer. As with some sports photography, wildlife, birds, and insects often won't allow you close enough to get a satisfactory image size on film when using normal or wide-angle lenses. For example, typical compact-camera pictures of deer grazing generally consist of lots and lots of foreground and trees with a few tiny images barely recognizable as deer off in the background. Attempting to get closer almost always results in the animals bolting. If wildlife is your true photographic interest, then you must be prepared to invest in an interchangeable-lens SLR and a telephoto lens. On the other hand, if your interests run only to photographing family pets, then compacts can do very nicely, providing you can keep three to four feet—the minimum focusing distance—between you and your pet.

Here is a compelling study of an often-photographed subject. Most of us would have shot down at the squirrel, but this photographer used a very long lens (at least 400mm) and got down to the subject's level.

David Mengle

Chandra Swami, M.D.

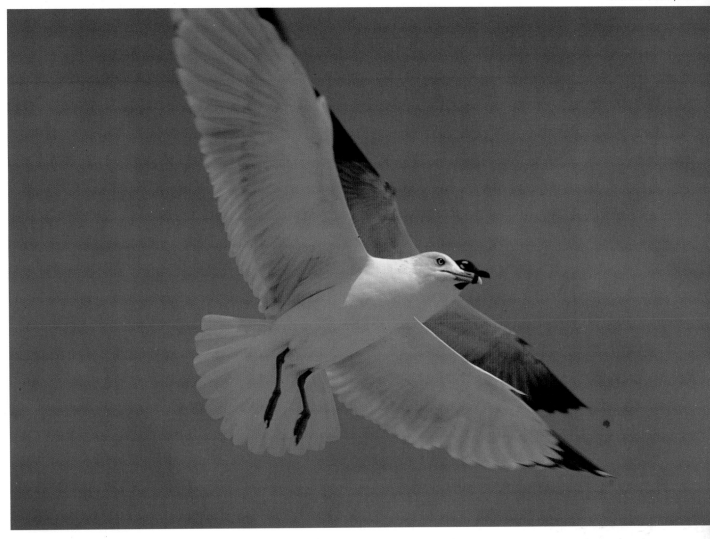

One key to making good animal photographs is understanding their habits. Can you predict what they'll do in specific situations? How close can you get without flushing them? If they run, which way will they usually go? Will they tolerate the noise of an autofocus lens? (For more detailed information on nature and wildlife photography, refer to the bibliography for some suggested readings.)

Appropriate lens choice helped make this picture possible. Choosing a high-speed telephoto of about 300mm, Chandra was able to utilize the top shutter speeds of his camera, filling the viewfinder with birds rather than sky.

Flash and Animal Photography. Several autofocus SLRs that can be equipped with long lenses can also be fitted with powerful, fully integrated camera-controlled flashes. These make excellent light sources for subjects within a range of two to thirty feet. Butterflies, many insects, domestic pets, and farm animals can all be photographed effectively with the daylight/flash combination offered by these versatile light sources. Also, using one of these flash units as the main light source in daylight situations will allow you to select a small f-stop (if aperture priority is an available camera-operating mode) while at the same time freezing all but the most rapid movement. For extreme closeup work where depth of field is critical, this flash feature can be invaluable. Several autofocus SLR camera/flash combinations can be set to operate in full automatic, meaning you only have to attach the flash, turn it and the camera on, and the camera/flash electronics do the rest, including film-speed indexing, metering, and proper control of the flash output. The flash heads on several units can even be swiveled and tilted to provide soft, reflected, bounced light.

SHOOTING AT THE ZOO

Zoos offer a rich source of animal subject matter, but the setting requires a number of specific adjustments if you hope to get good pictures. To begin with, much effective zoo photography requires a longer-than-normal lens. Unless you purposely intend to picture animals in a man-made environment complete with moats, cages, and bars, you'll probably want to photograph them so they appear to be in their natural habitat. To do this, look for ways to eliminate man-made constraints and structures as well as the other zoo visitors. Super-tight cropping is a method I've found useful. You get very close to the animals, either literally or with a telephoto lens.

Also, try to arrive very early or wait until almost closing—you'll have fewer people to deal with. Decide how you want to depict the animal, look for a perspective, and choose a lens that will highlight this. Zoom lenses in the 35–200mm or 70–210mm range are good choices here, for they offer a wide range of focal lengths and will give you compositional flexibility in the viewfinder. Both the baboon and elephant photos in this chapter were taken at a zoo, using some of the techniques described here. You probably can't shoot many pictures like this with the average compact one-lens autofocus camera, but you may be able to do it with a bi-lens compact and almost surely with an autofocus SLR and interchangeable lens. If the negative or slide you shoot is especially sharp but includes more incidental detail or background than you want, you can always crop out portions of the image and make a second-generation print or slide. However, you will suffer some loss of quality.

Two special times at zoos present especially interesting picture opportunities—feeding time and washing time. And don't forget the children's, or petting, zoo that offers an opportunity to get really close to a subject.

These two photographs were both taken at zoos; the elephant with an autofocus compact and the baboon with a top-of-the-line SLR.

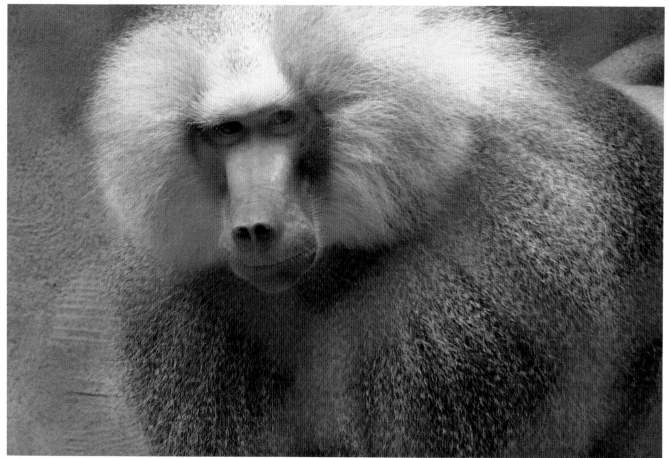

Chandra Swami, M.D.

There are times when a sixth sense—
some call it intuition—takes over. You
compose without composing and see
things without consciously realizing it. I
don't remember seeing the uncanny
similarity of line in these two horses.
Almost every detail is repeated from
mother to child, but I only discovered
that when I projected the slide.

SUGGESTIONS FOR IMPROVING ANIMAL PHOTOGRAPHS

As with other subjects, preplanning your animal shots is essential for success. Planning a shoot may require that you construct a blind, find ways to muffle the sound of the autofocus mechanism, and perhaps set up a remote-control flash. Detailed technical advice is beyond the scope of this chapter, but here are a few general tips for better animal shots:

• Choose the right equipment for the subject. Some cameras are simply unable to do what you want them to do. For example, a fixed-lens, compact autofocus camera cannot be expected to produce large, frame-filling images of wild animals two or three hundred feet away. To shoot these subjects, you need a camera that can accept 300–600mm telephoto lenses. The only autofocus cameras that accept these lenses are SLRs.

• Anticipate the animal's activity. Become a student of your subject's behavior.

• Get down to the level of the animal you are shooting. Try not to shoot at a subject from above.

• Shoot at wide apertures to eliminate unnecessary, distracting backgrounds.

• Shoot early in the morning or late in the day—the light is more dramatic and interesting.

• Choose the right film for the job. Don't expect a slow or moderate-speed film to do a good job in low-light photography of moving animals.

• Be patient. Many animals settle down after being around people for a while, particularly once they determine you are not a threat. You could miss a few early shots, but often you'll get some better ones later on.

• Find some way to muffle the sound of the autofocus mechanism. Wrapping a jacket or towel loosely around the lens is usually all that is needed.

• Don't attempt to lure wild animals closer by putting out food. You are only courting trouble. Even smaller animals you find endearing and cute may turn surprisingly aggressive if startled or emboldened by the prospect of a free meal.

4 TRAVEL AND RECREATION

Compact autofocus cameras are a good choice for the majority of vacationers and travelers. Photo equipment engineers must have had travelers in mind when they designed them. Ready at a moment's notice, they are terrific for on-the-go grab shooting. Actual in-use tests confirm that these compacts will deliver a higher percentage of sharply focused and well-exposed pictures than any other camera of comparable size and price, such as disc, instamatic, or conventional 35mm compacts.

A camera left in a hotel can't be used to take pictures—let alone to capture a once-in-a-lifetime shot—so it makes sense to select a camera that is easy to tote around but also offers the features you want. A light, portable camera system will probably get more use than a heavy multi-lens outfit. In my travels, I've found the compact autofocus camera is an ideal piece of equipment—light, easy to use, and dependable. It takes the worry out of shooting a million miles away from your color processor. With a practical eye for a shot, most people can take a good picture with the autofocus.

If you demand both ease of operation and utmost image quality, you might have to sacrifice some compactness for the operating sophistication of an autofocus SLR. Although the best compacts match the picture-taking ease of an SLR, they can't equal SLR's metering precision or lens versatility.

BASIC PLANNING CONSIDERATIONS

Preparing for a trip involves a number of considerations. Some deal with photo preplanning to anticipate and solve specific picture-taking problems. Others are aimed at integrating photography into your general vacation and

Get up very early every once in a while and shoot by the light of early dawn and sunrise. A few hours after this picture was taken, the beach was swarming with people, which would have made this picture much more difficult to get.

Steve Wheeler

66

travel plans. Obviously these two planning perspectives are not independent of one another; each has a direct bearing on the other. For example, it is wise to determine equipment and photo supply needs in the context of how much luggage you should or can take along. Decide what camera gear you'll carry with you at the same time that you decide what you'll pack. Seasoned photographer-travelers generally operate from two camera bags. The first and larger contains all the gear and film for an entire trip. From this bag they load into a second, smaller bag the film, cameras, and accessories that will be needed for the day's shooting.

Photo needs should also be considered when the overall trip itinerary is set. Unless you are just going to grab what pictures you can from place to place, you will want to put some time aside at certain points specifically for photography. When my wife and I travel, we have a constant tug of war between my need to stop, study, and then shoot and her desire to do anything but take pictures. The solution we usually arrive at is to allow each of us time to do our thing alone, unrestricted by the needs or desires of the other. For example, I love to shoot in the light of early mornings, while my wife, Pat, prefers to use that time to work up to the day's activities. So she sips her coffee and munches on a croissant, while I am out prowling the early morning streets. It's a great way for both of us to start the day. This kind of preplanning and arranging schedules pays handsome dividends while on vacation or traveling.

"Found" images are those wonderful discoveries that happen without planning or even forethought. You only need to be ready to take advantage of the opportunities. The seventeenth-century Irish convent pictured here is a prime example of a "found" image. My wife and I had the opportunity to spend some time in Ireland as guests of the Irish Tourist Board. By the fifth or sixth day we had become accustomed to narrow roads that become unpaved lanes for a while then pick up again as a legitimate thoroughfare. We learned to anticipate sharp turns. As we wheeled around one such turn we almost ran straight into the castle-like structure pictured above. I didn't have to do anything except raise the camera (an auto-focus zoom compact, with lens at 70mm) and shoot—it was all there. The light was just so, and the foreground led the eye to the structure, suitably framed by multishaded trees to the sides and in the background.

Experienced travelers who are also serious photographers are discovering that an autofocus SLR fitted with one or two zoom lenses generally fulfills their needs admirably. For these people, a typical travel kit would include a 28–85mm or 35–105mm main lens plus a longer 80–200mm or 70–210mm zoom. With just these two lenses, there are very few photo situations you can't deal with effectively. In fact, all the pictures used to illustrate this chapter were taken with lenses between 28mm and 200mm.

A friend who is a world traveler and top-notch architectural photographer asserts very bluntly that she has taken more than 80 percent of her impressive portfolio with a 35–105mm zoom lens. Other photographers confirm that figure as holding true for them, too. Why then do I recommend taking a 28–85mm along with the longer 70–210 zoom? First, because both lenses are relatively compact, but more importantly, because there are any number of situations that scream out for wider-than-35mm treatment; then again, some subjects just aren't accessible with a short 85mm telephoto. It is also fun and exciting to have the option of looking through the viewfinder of a 28mm lens at the narrow medieval streets of a European capital or of observing a group of locals from a discreet distance with a 200mm. Still, you'll find yourself using 35mm, 50mm, and 85mm lenses most often.

In practice, using lenses that are shorter or longer than these may be the only way to get some shots. However, if you are limited to only one lens, it is a good idea to opt for one covering all or the better part of the 35–105mm range. An interesting alternative to either an ordinary compact autofocus or the larger AF SLR is the zoom-lens compact autofocus. This camera affords the user the most lens flexibility of any compact, coupled with very good optical quality. Although it is a bit larger and heavier than its fixed-lens cousins, but after using one for an extended period of time, I am convinced it is an excellent camera and deserves serious consideration.

At times I take my picture taking too seriously. But this one was pure fun. It answers the question, what do you do with the side of a barn? I have several versions of this scene and feel the shadows make the picture more interesting to look at because they break up the wide expanse of solid white in the wall.

Wide-angle lenses exaggerate perspective, emphasizing the size of objects nearest the lens. My first temptation was to back off and shoot the entire scene, which is what I did. Then I found this wonderfully bizarre cattle skull was with about a dozen others stuck to a fence post right in someone's front yard.

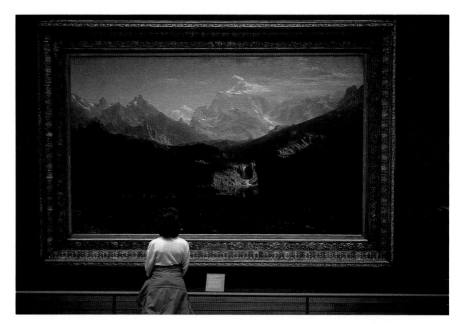

For this photograph, I used slide film color-balanced for the orangish tungsten lights typically encountered in older museums. I think the resulting color rendition is very close to what I remember it to be. I'm glad I included my daughter in the scene, because that added a new dimension to a more or less record photograph.

Film for the Road. I've found that most people don't take enough film or the correct mix on their trips. Typical vacationers shoot anywhere from a half to a whole 36-exposure roll of film per day; more active picture takers may shoot up to three 36-exposure rolls in the same period. Whichever the case, calculate your average needs and then add an additional 50 percent film reserve. You'll eventually shoot it up even if you don't use it on the trip.

Over 80 percent of all amateurs shoot color-print film. It's not that color-print film is necessarily any better than slide film, just that most casual photographers prefer to have finished prints rather than slides that need to be viewed or projected. Whichever film you use, it's a good idea to include a few rolls of high-speed film (ISO 1000–1600) along with your main supply of medium-speed film types (ISO 100–200). Also, if you intend to shoot slides, take a few rolls of tungsten-balanced film along (ISO 160)—it's specially designed to give good color under artificial lights such as the ones found in many museums. Be sure you either hand-check your film through airport security or protect it with any of the several types of lead-lined anti-X-ray bags designed for the purpose.

All 35mm film is now DX coded to provide the camera with film-speed information. The small black and silver checkerboard squares found on currently manufactured 35mm film cassettes are similar to universal product codes on practically all supermarket items. Presently, autofocus cameras are designed to read these codes and then set the proper film ISO. If you happen to load a noncoded film into your camera, it will probably set the film speed at ISO 100. To be sure, consult your camera's instruction book. Earlier autofocus cameras did not include DX circuitry: you just set the proper film speed in the traditional manner.

Such slow films as Kodachrome 25 and 64 and especially Fujichrome 50 yield brilliant, fully saturated color with lots of very fine detail, as you can see in this New England village image. Margaret Williams turned a pleasant but usual scene into something out of the ordinary by including the artist in the foreground. In doing this she changed both the content focus and the visual dynamics.

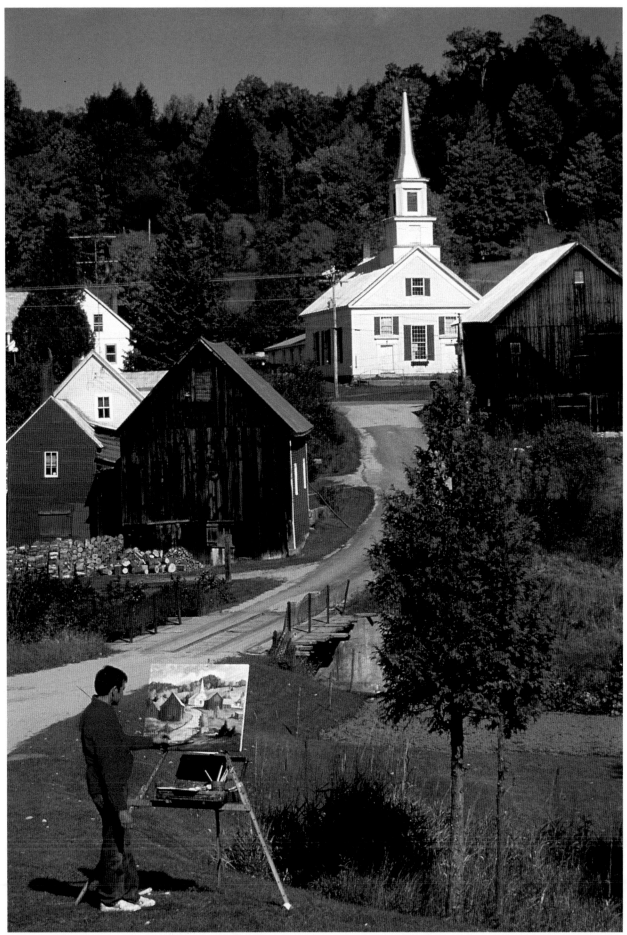

Margaret Williams

Bill Gourly

A very long exposure accounts for the distorted color rendition. The red streaks are nothing more than the running lights of smaller boats as they move through the scene. Distortions created by the long exposure result in a strikingly graphic presentation.

Batteries. Almost all modern cameras rely on batteries to power some or all systems. This is especially true of autofocus cameras, none of which operate without battery power. It is wise to carry at least one set of fresh spares for each battery type you use. Remember, battery availability may be severely limited in many locations, particularly for special photo types. I cannot emphasize too strongly that autofocus cameras are totally dependent on electrical power. Without battery power they are nothing more than very expensive paperweights. It pays not only to carry spares but to test all of them before your trip. To play it safe, also be sure to test the batteries you are already using. Most camera shops will provide this service free of charge. When you have batteries tested be sure to check them under load and read the heavy-use scales.

RECOMMENDED PHOTO ACCESSORIES

Tripod. Many people have found a small lightweight tripod a lifesaver in marginal lighting conditions where flash is either not permitted or not desirable. When absolute sharpness and detailed rendition are paramount considerations, there is no substitute for a tripod. Normally, I would suggest you use the most rigid tripod you can find, but it would almost certainly be a heavy brute. I don't think many travelers would be willing to lug around six to ten pounds of tripod ten hours a day.

A tripod to be used on a trip must be portable and reasonably lightweight. Too big or too heavy and it will never make it out of the hotel room. Something weighing around two pounds is the upper limit. If you are inclined to use a tripod when traveling, select the most rigid one you can find that is still light enough to carry around all day long.

A Travel Survival Kit. Provide yourself with a travel survival kit including several different sizes of clear plastic bags and rubber bands. These can be used to protect your cameras, flash, and lenses against rain or dust. Small items such as a roll of strong cloth gaffer tape; a set of small precision jeweler's screwdrivers; a can of compressed air for lens cleaning; and lens-cleaning tissue and fluid complete the kit.

A Flash Unit. If a flash is not built into your camera, which is the case with several AF SLRs, it is a good idea to take a small attachable unit with you to fill in shadows or provide light indoors. These flashes need not be large, elaborate affairs. Look for one with an ISO 100 guide number of at least 40. This should provide enough power to accomplish most reasonable flash tasks.

Filters and Polarizers. You may have noticed that so far I've not mentioned filters. That is because few compact autofocus cameras feature lenses threaded for conventional screw-in lens filters. Granted, filters can be used by holding them in place while taking a picture, but this is clumsy at best. Perhaps one day an enterprising manufacturer will offer adapters to facilitate the use of filters with these cameras, although when one thinks about it, filters do go against the point-and-shoot philosophy of many compact designs.

A tripod is essential if you expect to get high-quality fireworks. With medium-speed film (ISO 100–160), experts suggest an aperture of ƒ/11, keeping the lens on "T" or "B" setting. The lens should be set on "infinity." Totally automatic autofocus compacts won't deliver sharply defined fireworks because they lack user-adjustable shutters with "B" or "T" settings.

Bill Gourley

There's evidence from the very dark, almost black water and well-saturated color that the person who took the picture probably used a polarizer to absorb color-degrading reflections.

If you own an autofocus camera that can accommodate filters, I strongly recommend buying an ultraviolet filter and a polarizer. Ultraviolet filters are, first of all, useful as lens protectors. Far better to damage a ten-dollar ultraviolet filter than the prime lens itself. Also, these filters cut through haze, absorbing the excess of bluish ultraviolet radiation so that you record more pleasing color. They are especially useful on overcast days or when shooting subjects in shade. Polarizers also act to cut through haze somewhat, but their main function is to cut down on image-degrading reflections from nonmetallic surfaces. Because they absorb reflections, they can make photographs taken through glass or water much more vivid. In addition, they darken the daylight sky, increasing sky-cloud contrast dramatically. Although polarizers do require up to a two-stop increase in exposure, the dramatic color that results can be more than worth it.

GETTING TO KNOW A NEW LOCALE

One thing many of us forget is the reason for vacation or travel—to relax and have a good time. Instead of relaxing we try to pack as much as we can into the week or two, as if quantity of experience is more important than quality. Because of this mindset, I'm sure some people feel pressured to hit the streets as soon as they can dump the luggage in their room.

Traveling takes more energy than you may realize, so it is a good idea to rest up a bit. New and strange surroundings, no matter how exciting, will be temporarily disorienting. Even if you are vacationing at a resort, you are bound to feel a bit uncomfortable the first twelve hours or so. Take some time to unwind and regroup. Check your photo gear to make sure it survived the trip in good shape.

When you go out the first time, take the opportunity to observe your surroundings without a camera. What is different or interesting about the place? Any strong first impressions? Sounds, colors, smells? Are the people accessible? What do you think would make an exciting picture? Is it the architecture? Terrain? With these and other questions you can form some general impressions, then start to zero in on particular subject matter. It is quite important at this point not to shut out new or unexpected possibilities. Keep your eyes and mind open.

Dramatic lighting and interesting repetitive shapes highlight this interior, available-light image of a Moorish sultan's palace in Granada, Spain.

Stephen Mellus

A good deal of looking around resulted in this unusual New Orleans street portrait.

To my eye, the most interesting travel vacation images are those blending local architecture, other physical features, and people in an imaginative manner. While it is perfectly reasonable to shoot straight architecture or landscapes, combining the three can really bring the picture to life for viewers. Often it is the people you meet and photograph that you remember long after other details have faded out of mind.

I urge you to be receptive to photographing all kinds of people—people at work and at play. Find subjects who are animated, and work hard at establishing some sort of contact with them before you shoot. Sometimes a gesture or nod is all the permission that's necessary to take someone's picture. On the other hand, don't always expect to get permission. The Pennsylvania Amish in my own part of the country and most Moslem women in the Middle East, though often photographed as curiosities, have strong objections to the practice. However, except for these and similar groups, people are often genuinely flattered when asked to pose. Some locals even make a living as tourist models. It helps if you can figure out the local customs in this regard—at times, even a token remuneration of some kind can open up rich photo opportunities.

Bryce Jordan

People are the spice that flavor vacation and travel images. On the practical side, they often provide scale, thus aiding the viewer's reading of the image.

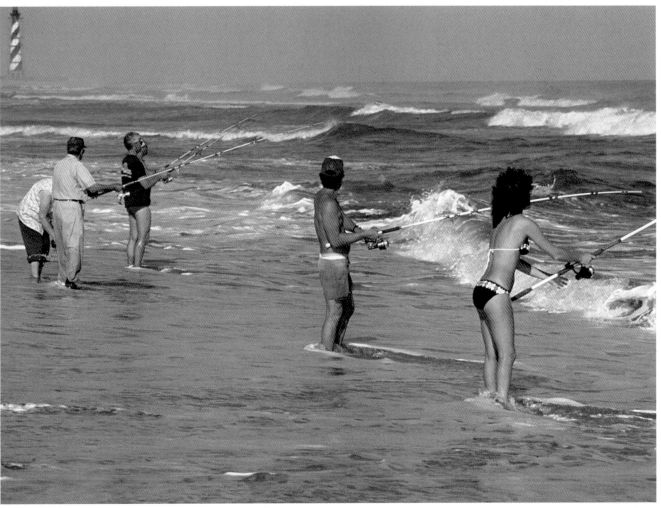

Richard L. Crowley

Paul Duda

The camera recorded this quiet Old World scene in an out-of-the-way location in Prague. The colorful flowers are balanced by an expanse of plain wall.

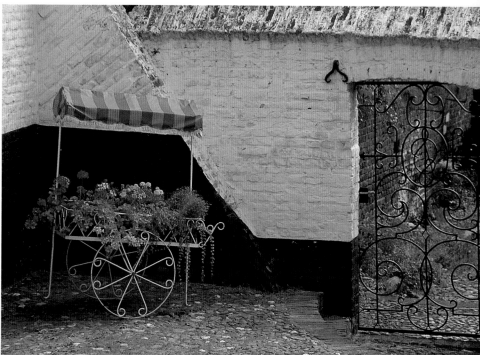

It can be something of an adventure to wander off and explore off-the-beaten-path shooting locations. To do this it is almost always necessary to get away from typical tourist attractions. In some places you visit, exploring such territory may involve an element of risk. A stranger in an out-of-the-way neighborhood can be the object of suspicion or even the target of violence. How can you minimize the risks? One method is to hire a local guide. Many cities provide lists of approved individuals who are certified or licensed. Overseas, you can find lots of school-age kids willing to be your guide for a daily fee that is usually fair. Select the most intelligent person you can find, one who is fairly fluent in your language. The sharper the guide is, the more useful he or she will be to you. Explain exactly what you want to photograph. A guide who is at all street smart will be able to screen you from hustlers and peddlers and may even be able to persuade normally reticent subjects to pose for you. Best of all, a good guide can lead you to little-seen locations in relative safety. It's amazing how many doors open wide when you have a native speaker guiding you.

When I told a member of the Irish Tourist Board that I was interested in a typically Irish scene, she gave me directions to locations like the one pictured here. I call it "Lace Curtain Irish."

Margaret Williams

Asking questions of local residents can
often lead you to subjects you would
never have found on your own, such as
this geometric study.

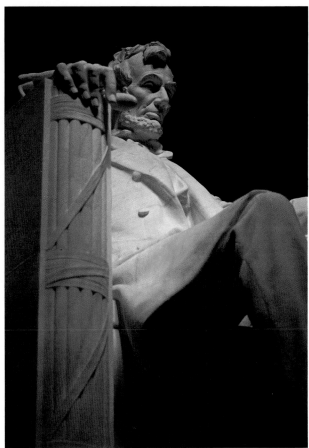

These two pictures are good examples of how to use the wrong film at the right time—I made both pictures with daylight-balanced color film under tungsten light.

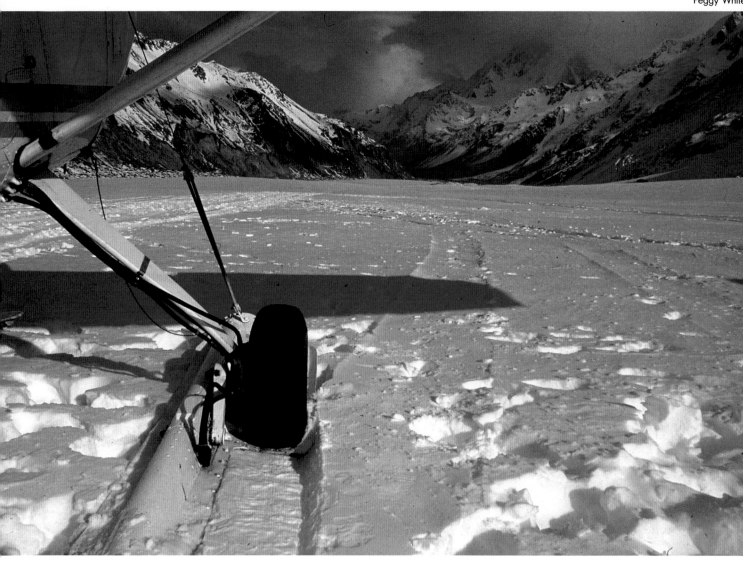

Quite often pictures serve to remind us of what we've experienced. Like this photographer, I have a few images that in one 1×1½-inch rectangle encapsulate a whole range of experiences. This photograph, taken on the Tasman Glacier in New Zealand, is one of those rare pictures.

CAPTURING THE VISUAL SENSE

Sensitivity to subject is far more important than technical expertise. Awareness can direct your eye so the pictures you take reflect your appreciation of the subject. But how does the typical photographer become a sensitive observer? The first step, I think, is to direct your eye and mind with a series of questions: What do you want to remember about the subject? Do you have feelings about it you can identify? What colors, shapes, smells, patterns, or special characteristics are memorable? What would pictures of these sensations and experiences look like? The one question always in mind should be, how can you photograph your experiences so they look like more than flat documentary records?

Asking yourself such questions can be both rewarding and frustrating. But they get the creative juices going, even if you don't always have a ready answer. Posing these questions as you study a scene through the viewfinder will probably prompt you to see things you were unaware of previously. Once this begins to happen, it is only a matter of engaging your mind and eye in the act of mental editing. After that the AF camera can take over.

PHOTOGRAPHING MUSEUMS AND GALLERIES

Lots of people enjoy gallery roaming. For some it is a regular recreational activity. For others it is something they do only on holiday. If you wish to take photos in a museum or gallery, here are some guidelines to follow:

• Find out what restrictions the management places on photography. These vary greatly from place to place.

• Almost no gallery or museum permits flash photography, so you'll need to deal with artificial or mixed lighting frequently. Sometimes moderately fast tungsten-balanced color film will yield acceptable results. Bear in mind that many compact autofocus cameras can be used successfully in moderately well-lit museums without resorting to flash. You will need to load one of the new, super-fast, ISO 1000–3200 films, provided your camera's metering system can accommodate such fast emulsions.

• Although some galleries permit tripods, many don't. However, a good many will allow the use of a monopod, which can add just enough stability to deliver sharp images. In the absence of a formal camera support, try using a handy wall or railing to brace the camera, or use your body.

• Include people in a few of the gallery shots. Sometimes they provide visual scale or add an interesting element of contrast to a particular subject.

• The best times for photography in museums are usually very early in the day during the week instead of on the weekend, when the crush of people generally makes photography all but impossible.

• Museums attract lots of different and unusual people—foreign tourists, families, local characters, and often street performers and sidewalk artists. The photo potential in these subjects is extensive.

• The architecture of museums and galleries themselves can be the source of photo inspiration. Don't overlook them.

Betsy Wertz

Sometimes you find more interesting things to photograph around the outside of a museum than in it. By selectively cropping in the viewfinder, Betsy Wertz presents her distillation of what must be a far larger subject. I suspect this eye-catching rendition has far more visual appeal than almost any straight shot of the entire piece.

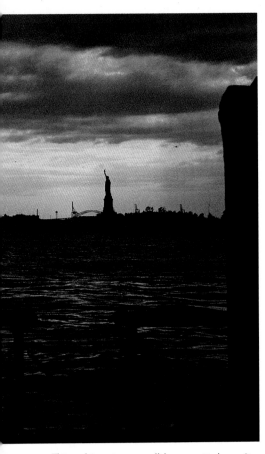

This subject is so well known, it doesn't need to occupy very much space to remain the center of attention.

Taking the picture of Big Ben in London on the opposite page was actually quite simple. First, it is a night shot, so I used a small, light tripod. I lay down on the sidewalk, slipped the tripod with camera attached under the fence grating surrounding the building, and angled the camera upward. I then let the automatic systems take over. I don't remember if I was able to look in the viewfinder or not. The resulting transparency is very dramatic, particularly when shown on a large screen or presented in a gallery as a very large print.

PHOTO ORGANIZATIONS

A local or nationally affiliated photo club or association often can provide entree to choice photographic locations near your home and abroad. A bit of research might be required to find key individuals in these clubs, but frequently all it takes is a phone call to a camera shop in the town you are visiting. National photo organizations provide lots of help for traveling photographers through individuals designated as photo guides and local chapter members who are receptive and hospitable to traveling colleagues.

In the United States, the Photographic Society of America (PSA) is the premier organization. In addition to many thousands of stateside members, the Society boasts more then 1,000 members in over 130 foreign chapters. PSA publishes two directories of interest. The first is the general *PSA Membership Directory*, listing all members alphabetically and by city and country. The second is the *PSA Travel Aid Directory*, listing volunteer society members who are willing to provide local information. Some will offer other assistance as well.

SLIDE SHOWS AND DISPLAYS

Unfortunately, much travel photography is wasted because nothing is done with it after the trip is over. Pictures end up languishing in the closet or drawer. I have found transparencies easier to present than prints. A 40×40-inch projected slide image is far more impressive than a 3×5-inch or 4×6-inch print. Also, slides are easier to use with music or a recorded narration. On the other hand, an indifferently arranged slide show is deadly. To avoid this, here are a few suggestions to make your slide shows more effective.

- Don't oversaturate viewers. A set of fifty to eighty carefully arranged slides is far better than a typical show containing two or three times that number.

- Establish themes as you go through your slides, perhaps the same themes you identified when you took the pictures.

- Arrange your slides in some order: chronologically, by subject, location, or whatever seems your most suitable structure.

- Set up the show sequence in such a way that there is a definite beginning, middle, and end. You can do this by starting with a few "establishing shots," such as those taken at departure from the airport, then follow with the main body of the show and finish with the return.

- Vary the presentation as much as possible. Mix vertical with horizontal formats, and limit the number of pictures of the same subject to two or three at most. Variety is very important to maintain viewer interest.

- Select pictures that tell a story, have emotional appeal, or both. Consider adding music to reinforce the mood you want to create.

- When you narrate, keep it brief but animated. The excitement you project is catching.

- Build up to some sort of finale, perhaps by saving some particularly eye-popping slides until the very end.

FIFTEEN GUIDELINES TO IMPROVE VACATION/TRAVEL PICTURES

1. Look for imaginative vantage points. What is it that grabs your eye?

2. Scout the area before you shoot and work to gain an understanding of the overall "feel" of a locale.

3. Explore out-of-the-way subjects. They are often more fascinating than conventional ones.

4. Include people whenever possible.

5. Seek out architectural details.

6. Shoot in the rain or snow. Color looks great and can produce moody, unusual renditions of otherwise common subjects.

7. A few small, clear plastic food storage bags and rubber bands will protect your camera from rain or snow, while an ultraviolet filter and shade afford ample lens protection. If you anticipate lots of bad-weather photography or wish to shoot in the surf on board a small boat, consider purchasing one of the new waterproof or moisture-resistant autofocus compacts.

8. Shoot lots of pictures—most vacationers shoot far too few.

9. Experiment with new techniques. Shoot some slow-shutter-speed pictures. Follow fast-moving action by panning.

10. Fill the entire viewfinder with the subject, not a lot of extraneous material. Move in close.

11. Study the light. The most dramatic lighting occurs before 10 AM and after 3 PM. An average subject at noon may have less visual impact than in the setting sun at 7 PM.

12. Except when first scouting an area you'll be returning to over and over, carry a camera at all times. Have it loaded and turned on.

13. Remember that wide-angle lenses tend to expand a scene, while telephoto lenses seem to compress subjects from front to rear.

14. Before you press the shutter release, make sure you like what you see in the viewfinder. If you don't, do something about it.

15. Travel as light as possible.

Quiet pictures can paradoxically be dynamic. Many people viewing this image comment on the energy created by the diagonal split between light and shadow.

Powerful contrasts between light and strong shadows create fascinating patterns on the sand.

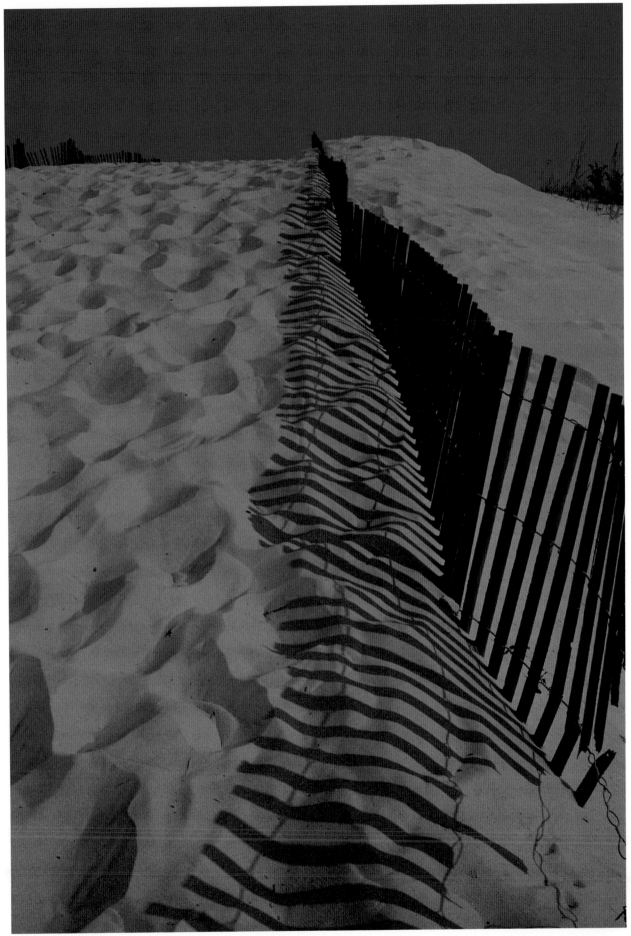

Betsy Wertz

5 STILL PHOTOGRAPHY

One of the current debates concerning autofocus centers on the question of its usefulness for the complete range of photographic subjects. I suppose an argument could be made that autofocus is well suited to fast-breaking action, sports, or wildlife work and is but an unimportant frill for more contemplative, slow-paced subjects—landscapes, closeups, still lifes, or architecture. In practice, this is not the case. Ten years experience has convinced me that autofocus, contrary to popular belief, is extremely beneficial in the picture-taking situations addressed in this chapter. Let me suggest some reasons for this.

Because autofocus cameras are designed to deliver consistent focusing accuracy not possible with manual focusing, when properly employed and integrated into an overall creative approach to picture taking, they can help us better understand potential subjects. Autofocus relieves us of the task of focusing, so that we can devote more attention to the content and meaning of what we see. We no longer need be so preoccupied with the mere mechanics of picture taking. For me, this new freedom applies to both fast- and slow-paced subjects.

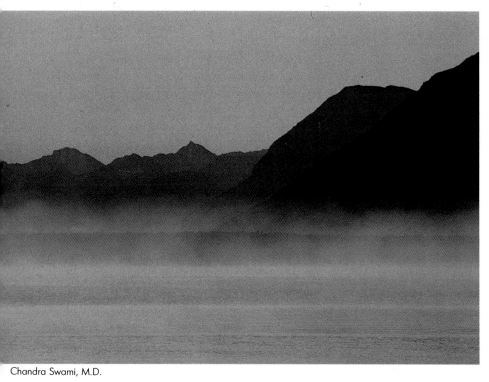

Chandra Swami, M.D.

Shooting landscapes is not always a mundane, slow-paced activity. At sunrise or sunset, light changes in a fraction of a second, and the feeling of a particular scene can be altered dramatically. You must be prepared for such fleeting instants of discovery as the one presented here. A photographer has to react very quickly to "freeze" a particular instant. A wonderful thing about this location is that there is always a mist or light fog in one or more directions. The interaction of diffused light through clean mist can be very impressive.

By midmorning the light changes drastically. Gone is any semblance of mist or fog—in its place, there is crystal clear "you can see forever" light. In the picture on the opposite page, the light was sharp and direct and created lots of contrast with very well-defined shadows. I had to work quickly, because the shadows were shifting as the sun moved through the morning sky, and differences in the quality of light create different feelings. Note the deep blue polarized sky. (I used a 28–85mm zoom at the 28mm setting.)

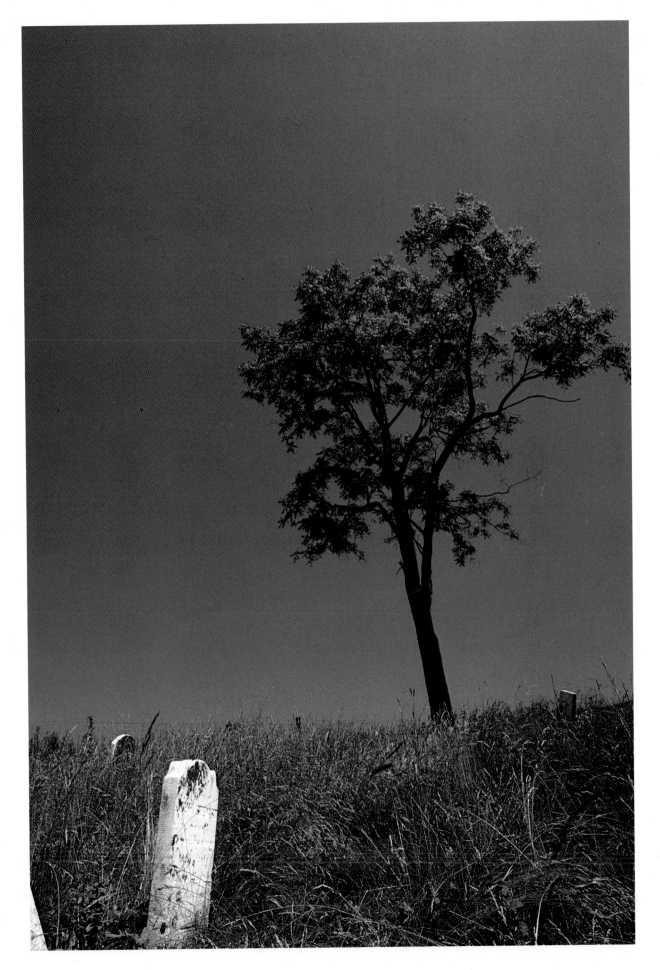

Once I began to trust the autofocus system I was using and gained confidence in its ability to do what its designers claimed it could, I found myself seeing images within the viewfinder in a new way. Previously, I usually composed from side to side, beginning within the central third of the image, sometimes paying little or no attention to edges or corners. I constantly found myself going back to the center of the viewfinder to check focusing accuracy. Invariably, I would tweak the focus to check final adjustment—more from habit than anything else. Since the autofocus camera I use gives me both visual and audio in-focus confirmation, I have been able to pay markedly less attention to the central third of the image. I now design an image in the viewfinder as a whole and work it not only from side to side but from front to rear. People tell me that the images I've produced since this rethinking of my technique are much more complete and more visually interesting. I know my autofocus camera does a better focusing job than I can manually, so I've trained myself to leave almost all focusing chores to the camera. My observations of dozens of autofocus users confirms that they do too.

This is an example of an image in which a perspective, or camera angle, was selected to highlight a unique line and shape. Brilliant late-afternoon light reflecting from rails creates a shimmering, flowing design.

Classical rules of composition advise against placing important content on the edges or near the corners of the frame, warning that in doing so one risks losing the viewer's attention. To me, rules like these are much too restrictive. I would suggest instead a guideline that stresses having reasons for organizing images in a particular way. If it works to place important content at the edges of the frame, do it.

Bill Gourly

Jack Loftus

This picture was an experiment in which the exact point of focus and the shutter speed selected (1/8 sec.) combined to create a rather different treatment of an otherwise ordinary stream. Autofocus allowed me to place the camera on a road going over a small bridge facing the flowing water. I could then operate the controls from the top and sight the camera much like a rifle. I took three pictures, moving the camera slightly before each shot.

Landscape, still-life, closeup and architectural photography take a great deal of visual organization to accurately reflect the photographer's intent. Now autofocus photographers can consider their photographic intent first and foremost. Automation, properly understood, leads to a re-ordering of photo priorities. Most photographers aren't particularly confident about focusing techniques or light metering anyway. Automating these functions will lead to more interesting and satisfying pictures. Using the autofocus, I become more aware of the scene as a whole and more quickly come to an understanding of what I am after. My editorial sense is more acute. If autofocus gives you an opportunity to re-order your visual priorities, it just might help to get you out of a visual rut.

Watching photographers focus on still-life subjects can be very illuminating. Although we know that the object cannot move, many of us still spend a great deal of time deliberately focusing the subject right up to the instant of taking the picture. How successfully we focus is almost an accident of when in the focusing-refocusing cycle we decide to press the shutter release. Sometimes we chose the right instant. Sometimes we don't.

While all autofocus systems can be employed to help us see more effectively and ensure sharply focused images to one degree or another, it is the *continuous* autofocus system that offers the greatest potential as an aid to photographers striving to respond to what they see and feel. As we noted in discussing sports photography, continuous autofocus is the closest thing to real-time focusing available, manual or automatic.

Continuous autofocus systems, many of which are exquisitely sensitive, can respond to minute changes in camera-to-subject distance, just as long as the system is engaged. Assuming one selects a sufficiently fast shutter speed, a continuous autofocus system can virtually guarantee sharp focus precisely where you want it. At its best, autofocus can make this critical part of the image-making process a servant to the creative, thinking photographer, allowing a degree of focusing precision and correctness heretofore unobtainable by most photographers. Because what we are presented with in the viewfinder is less cluttered and we can leave it to the camera to find correct focus, with autofocus we can consider questions of composition and design as primary concerns rather than as afterthoughts to attend to hastily after priming the camera to shoot.

Using telephoto lenses, especially those over 200mm, calls for great care in shutter-speed selection and focusing. Since these lenses offer little depth of field compared to their shorter-focal-length siblings, there is less room for error. Focus has to be right where you want it to be. If the point of focus had been slightly ahead or behind where it actually is, the entire feeling would have been altered.

LANDSCAPE PHOTOGRAPHY

When I first pondered the merits of autofocus for typical landscape subjects, I must admit I was hard pressed to find distinct advantages over conventional manual focusing. But that was before I actually began using autofocus in my landscape work. What soon became apparent was just what I had discovered when using autofocus with other subject matter—confidence in the capabilities of the camera's automatic systems allowed me to consider the scene presented in the viewfinder in a new and very startling way.

First, I found almost all autofocus viewfinders, and especially autofocus SLRs, much "cleaner"—that is, much less cluttered than their nonautofocusing cousins. Gone, for the most part, are coincidence rangefinder patches, microprisms, or split-image SLR rangefinder lines. Because it is no longer absolutely essential to include these conventional focus aids, the central portion of the viewing area is less obstructed with lines and circles. As a result, the center of the viewfinder is less psychologically dominant.

Autofocus viewfinders present a seemingly wider, more open picture. I now find myself far less fixated on the central portion of the viewfinder image and therefore more able to see all the visual elements in the scene—center, corners, and edges, as well as color, form, texture, light, and so on. This is not to say this understanding came to me instantly. No, it evolved over a period of several months of intensive shooting.

Without clouds and the farmhouse this image would be void of any arresting features. As a projected transparency filling a 50 × 50-inch screen, the farmhouse does its job of attracting the viewer's attention, providing something interesting to pull the viewer's eye into the frame. As an 8 × 10-inch print, however, the farmhouse might be too small to work effectively, even though it occupies the exact same percent of space as in the projected image. (I used an autofocus SLR equipped with a 20mm ultra-wide-angle lens.)

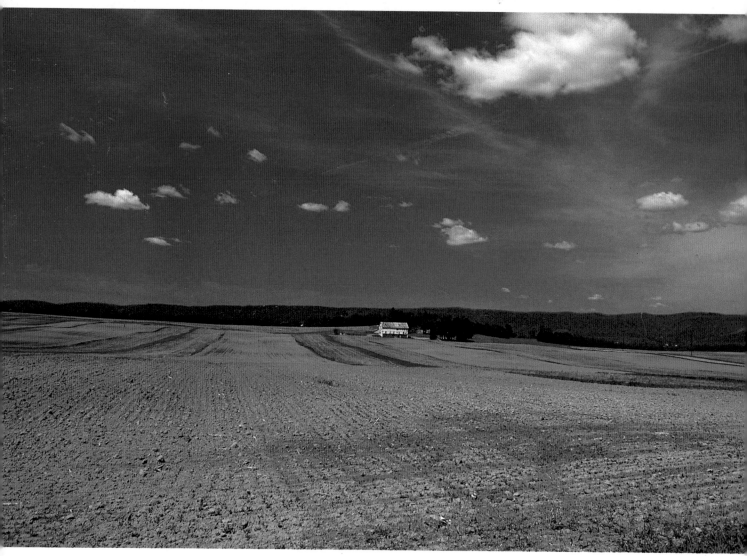

As I became accustomed to several autofocus systems in a number of different cameras, I created a different approach to landscape subjects. Using a totally automatic autofocus camera, which I knew would make any necessary technical adjustments, I had only to consider what the scene should look like as a photograph and then decide whether I might want to shift the point of sharpest focus by moving the camera. Of course, for autofocus cameras with more creative options, such as AF SLRs, there will still be questions of exposure modification and a choice of the focal length of lenses.

I discovered autofocus had another positive effect on my landscape work. As I thought more about how to compose landscape photographs, I realized that many photographers do not take enough care or time when shooting landscapes or scenics in general. Sometimes indifferently focused scenic images only convey the photographer's intent by accident. Where one focuses dictates where the viewer's eye is directed in the picture. Viewers look first at the sharpest part of the picture. Less sharp portions get a quick scan afterwards. It is important to control this variable if we want anyone to share our understanding of the subject.

Additional difficulties arise because many of us use wide-angle lenses for our scenic work. This lens type is the most difficult to focus accurately by hand. But I have found absolutely no problem focusing wide-angle autofocus lenses. They focus far more easily than their manual counterparts. Focus is achieved swiftly and with a precision just not possible with manual focusing of wide-angle lenses. You can place the precise point of focus right where you want it rather than at a vague approximation.

Sometimes the meaning of a subject can be greatly enhanced by selective focus. In this image titled "Death of the Family Farm," I chose to focus on the wire fence and allowed the farm buildings in the background to soften, hoping to evoke feelings implied by the title. This picture is also an example of a somewhat unpopular notion I subscribe to—that landscapes or scenics do not need to be beautiful or even pleasant subjects.

There are a number of painters and photographers, some well known, some unknown, whom I admire greatly, and many times I try to emulate their general approach. What I'm talking about is tutelage, not imitation.

Landscape is everywhere, and urban scenes are no less exciting or challenging than any country scene. I call this image a graphic—basic elements of line, form, and color combining to present a clean, uncluttered view of one facet of the urban scene.

The advantage of SLR autofocus with wide-angle lenses is especially apparent on gray, overcast, or hazy days offering little scene contrast to aid in accurate manual focusing. However, remember that even autofocus lenses need some scene contrast to work well, but until their low-contrast limit is reached, wide-angle autofocus systems in SLRs will outperform manual systems.

In difficult lighting, such as in that sweet time just after sunset when I especially like to work, the more sophisticated autofocus systems focus a wide-angle lens far better than I can manually. This advantage becomes abundantly clear when I examine comparison shots taken with both manual and autofocus wide angles. Low light usually calls for large apertures, thus limiting depth of field. Because there is so little depth of field to play with, determining the actual point of sharp focus becomes even more important. Autofocus is more consistent in this regard, so it is my preferred wide-angle camera. Under these conditions, manual focusing becomes something of a guessing game. Autofocus will generally focus accurately right down to its low-light limit.

Chandra Swami, M.D.

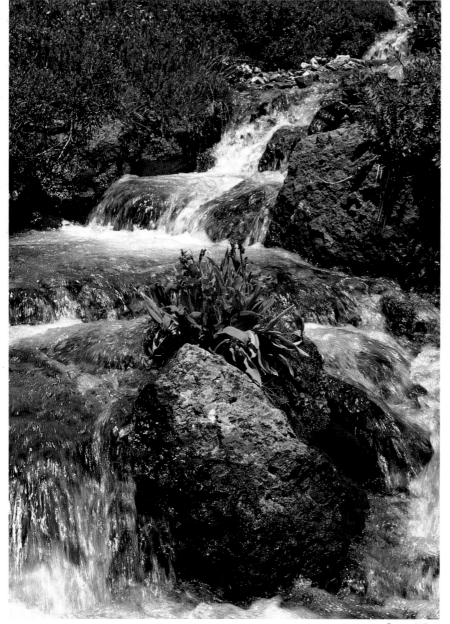

Peggy White

In landscape or scenic photography, whether in the city or country, wide-angle lenses can be very useful. Remember to provide a central point of interest, such as the large rock at the bottom of the frame here. Everything else then visually flows to it.

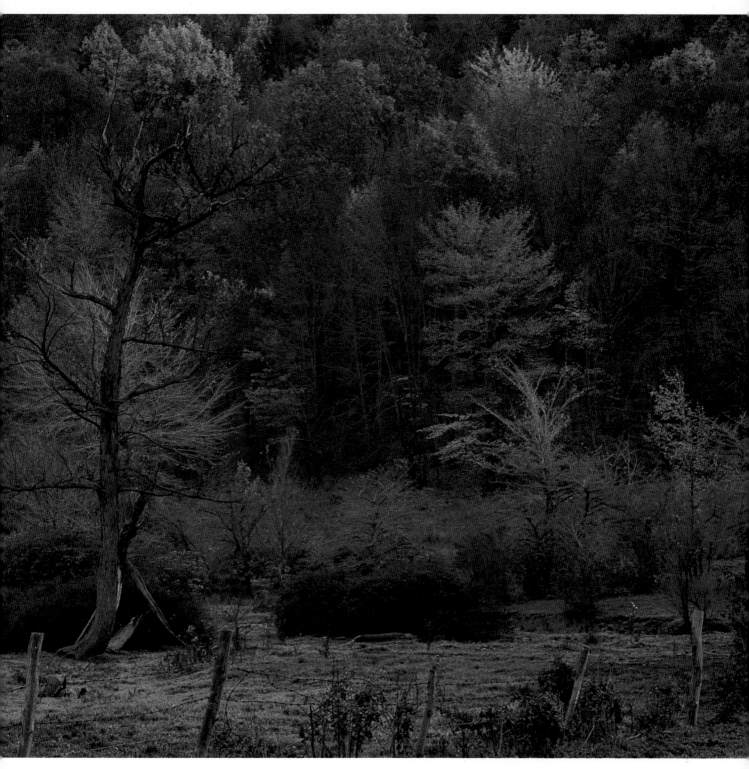

Dark, somber lighting emphasizes the deep, rich colors of late autumn. Deliberate underexposure created this look. Shot in different light or at another time of day, this scene would have taken on another character.

ARCHITECTURAL PHOTOGRAPHY

Much of what has been said about the landscape also applies to making architectural photographs. One nice feature of almost all autofocus compacts is their standard wide-angle lens of 35–40mm. This particular lens focal length is quite handy for many architectural subjects such as residences and short buildings, particularly when a vertical format is chosen. With wide angles, there is less need to tilt the camera upward to take in the entire structure. This in turn cuts down on the amount of convergent distortion, that "toppling over" effect often seen in pictures of tall buildings shot from a close distance.

Also important to architectural work is the awareness that detail is often more interesting than the structure as a whole. Capturing image detail requires some closeup capability, and the closer one gets to the subject the more critical accurate focus becomes. If you are interested in architectural photography, consider an autofocus compact that focuses closer than three or four feet or an autofocus SLR. (See also the section on macro/micro work, which has some direct applications to architectural photography.)

In several important respects, architectural photography is similar to landscape work. (Less is often more, "a ripple not a splash.") Choosing a part to represent the whole truly incorporates the essential quality of a structure. Individual details are often far more interesting than the entire structure.

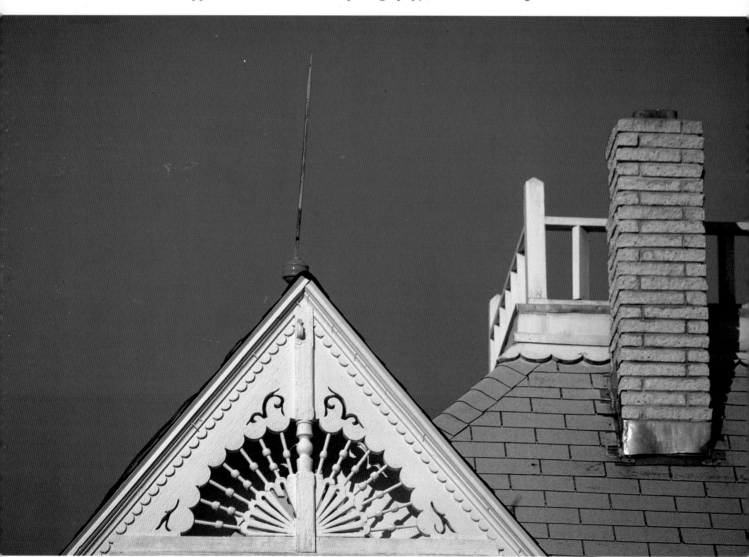

ABSTRACT PHOTOGRAPHY

The abstract in photography is difficult to define. It is, I suspect, the ultimate in symbolic imagery—a symbol being used to stand for or represent something else. Strong lines might be used to symbolize power or energy moving in a given direction, an everyday subject to epitomize some facet of contemporary life-style. Things we see may conjure up an association with something else totally unrelated to the physical subject before the camera.

To make symbolic connections through a photograph successfully, it is important to free your image of all other distractions. The autofocus camera, featuring programmed exposure and motorized film advance, is a very apt tool for exploring the abstract. The camera takes care of the how, and you are free to concentrate on the what.

As we've noted previously, total automation does not necessarily ensure excellence in image making. In fact, the opposite may be true. It is better to understand the limitations as well as the potential of the system and to use it intelligently. Automation is only an aid when it is smoothly integrated into your thinking, and that includes taking into account its operational limitations. Cameras themselves don't create anything—they only record what is. And while automation, especially autofocus, can help free you to redirect your picture taking away from rote, mechanical tasks, you must still learn how to communicate your understanding of what you see and wish to share in a photograph. Automation doesn't *create* meaning, but it can make it more accessible. This is especially true with subject matter so abstract that meaning is at times buried or so subtle that it has to be coaxed out. The accompanying pictures are better testimony to this than words.

Taking pictures of antique cars with modern sharp lenses can create contradictions. Here again I decided to test my imagination. Shutter speed ¼ sec., slow panning.

Bud Lewis

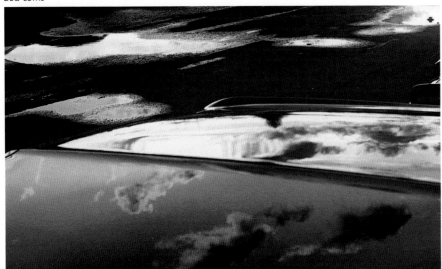

You can appreciate the image without knowing what it is.

Almost all of us take flower pictures at one time or other, and for years I've struggled to produce different interpretations of what is of itself already beautiful and often spectacular. Here's one that I think I got right. To set the tulip "on fire," I simply used flash outdoors, with a polarizer over the lens, and induced the soft-focus fog effect by breathing on the lens.

This picture is an example of three-dimensional macro work. I used a macro lens at its next-to-smallest aperture to extract as much fine detail from the subject as I could.

MACRO PHOTOGRAPHY

Nowhere in photography is precise control of focus and depth of field more central to effective image making than in closeup, or macro, work. When taking pictures at even a moderate degree of magnification—1/5 or 1/4 life-size, for example—very slight shifts in focus can have a devastating effect on overall image rendition. Bear in mind that in the macro range—1/2 life-size and greater image magnification—depth of field is measured in millimeters or even fractions of a millimeter.

Closeup photography can be divided into two categories: (1) two-dimensional closeup work such as copying, and (2) three-dimensional studio or field photography. The first type, most commonly used with copying, can be thought of in the same way as straight photography but with two additional caveats: Extra care must be taken to align the camera and subject so that straight lines remain straight without any keystoning, which is done by keeping the camera and subject parallel. Also, your focus must be right on.

Most photographers engage in three-dimensional macro photography more often than two-dimensional macro photography. The problems of field photography are somewhat different and to a degree more complex than copystand work because you have to deal with additional front-to-rear relationships that are not a factor in two-dimensional copy work. Composing at very short subject-to-camera distances demands careful attention to focusing. Depending upon the actual point of focus as well as the f-stop used, you may get different renditions of the same subject. Autofocus, particularly contrast-comparison SLR autofocus, works well to ensure proper focus even after accurate initial focusing. At times a very slight jarring of the camera or even a soft breeze can alter camera-to-subject distance enough to change the pictorial quality of the image. In other words, the critical focus shifts away from the intended principal subject to something slightly in front or back of it. Using autofocus, especially continuous autofocus, makes refocusing for closeups much, much easier. In the past I experienced frustration because I was forced constantly to readjust the focus manually. Every time the camera or subject moved even slightly, the point of focus altered, and focusing itself affected camera position. Electronic focus, found on almost every autofocus SLR, on the other hand, induces very little physical movement, and if an autofocus camera is equipped with an electronic cable release, there should be no movement at all.

This is a crystal I photographed through a microscope, using a technique known as Birefringant lighting, a type of double cross-polarization. As I recall, the image was made at a magnification of 125×. (Keep in mind that when objects are magnified, any camera movement and focusing error will be magnified by the same degree.) The camera was an autofocus SLR mounted on a microscope with an adaptor.

Chandra Swami, M.D.

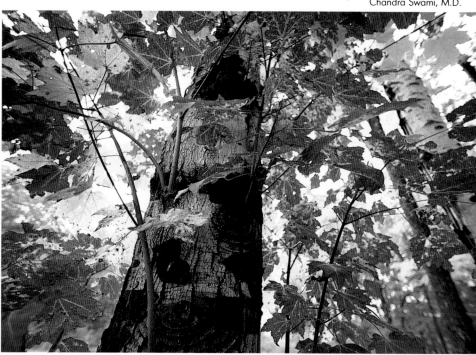

I like the dramatic accent provided by the black bark as this picture moves upward forcefully.

Earlier in this chapter I outlined the virtues of clear, uncluttered viewing and focusing, especially when using autofocus SLRs. There is a real advantage to using a camera with a clean, unadorned viewfinder when composing and designing three-dimensional macro shots. Many photographers have found manual focusing aids are so distracting at high magnifications that they can all but preclude full comprehension of the subject. At least for me, autofocus has changed that.

As with landscape, scenic, and still life photography, when working with macro subjects, autofocus helps photographers:

- Clarify the image in the viewfinder for more effective and unhindered composition and visual editing

- Exercise greater control over depth-of-field placement with AF cameras that permit depth-of-field manipulation

- Experience a more intimate and immediate relationship with the subject

- Maintain focusing control without the manual manipulation and readjustment that conventional methods require

- Achieve greater focusing precision, speed, and consistency

Be aware that no autofocus compact gives precise distance information or indicates the f-stop selected, so it is virtually impossible to compute depth of field. This is a serious omission in upper-end compact cameras and could be rectified by the manufacturers. When using an autofocus SLR, however, depth of field can be calculated with any camera if you know the subject-to-camera distance, f-stop in use, and the focal length of the lens. You need only consult a depth-of-field table. Also, many autofocus SLR lenses have depth-of-field guides engraved on their lens barrels, which give a rough approximation of available depth of field. Some AF SLRs provide a depth-of-field button or switch that stops the lens down to the correct aperture. You can then previsualize depth of field right in the viewfinder.

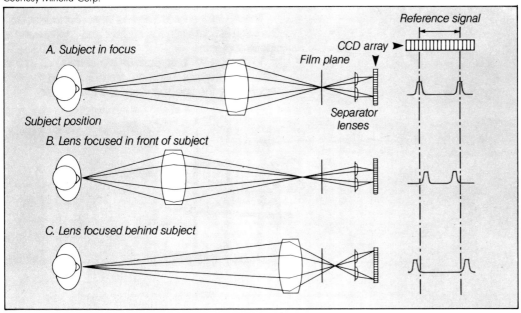

A. Subject in focus

Reference signal

CCD array

Film plane

Subject position

Separator lenses

B. Lens focused in front of subject

C. Lens focused behind subject

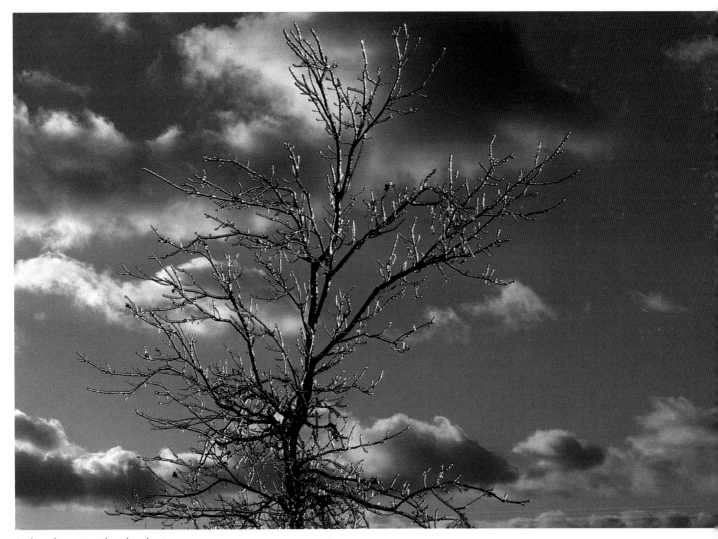

Isolated against the sky, the icy branches of the bare tree stand out in stark contrast.

Bryce Jordan

PHOTOGRAPHING PEOPLE

Autofocus supports effective portraiture by simplifying the process of photography for both the subject and the photographer. Traditionally, portraiture has been looked upon as an indoor activity taking place mainly in a specially designed studio. However, today more and more portraitists are moving away from the studio to outside locations, and candid work in out-of-studio settings is now enjoying great popularity. (Photographers are increasingly using candid techniques even in formal indoor settings to achieve a more natural look in portraits.) This trend introduces a number of benefits but a few disadvantages as well.

In candid portraiture, the photographer and subject are aware of one another and the purpose of the photo session. In reportage/photojournalism, which has grown into a separate form of photography, the emphasis is on unposed pictures often caught on the run. Much of what is most interesting and innovative in the field today can be found in the portfolios of photojournalists (including street photographers). Because of the differences, I've chosen to treat reportage/photojournalism as a separate topic in the last portion of this chapter; however, much of what is important to take into account with formal and candid portraiture work applies to photojournalism as well.

Jack Loftus

Compared to traditional studio portraiture, contemporary formal portraiture has a casual, informal look to it. In this appealing portrait of his daughter, the photographer combined tight cropping with beautiful soft focus to achieve an ethereal feeling.

This picture of a father with his young daughter on the opposite page is also very contemporary, but the methodology used is different from that of the preceding illustration. Taken outdoors on very-high-speed Fuji slide film (ISO 1600 rated at 800), the image has a biting, sharp-edged quality to it.

FORMAL PORTRAITS

Most traditional photoportraitists, working as they do from studios, have long preferred using a large-format view camera. As film quality improves and autofocus makes its way into medium-format camera designs, view cameras will probably become less important than they once were. Many studio photographers are gradually shifting to smaller, more versatile cameras.

A studio provides a photographer with the only place where there is total control over all the physical variables—subject lighting, background choice, weather conditions, props, and outside interruption. Because all the variables are controllable, creating a specific look or mood in a picture is often easier in the studio than on location. The tricky part of studio photography, including formal portraiture, is to make a picture that doesn't look stilted or contrived—in other words, to get an image that is as natural as possible. To accomplish this, photographers working in studios turn to techniques such as back and front projection to create "environments" in the studio. In this way they can simulate locations without going to the time and expense of building a background or set.

Of course, formal portraits need not be taken in a photographer's studio. You can very easily set up a makeshift studio in your home. A den or family room can quickly be converted with the use of a roll of seamless background paper and three or four floodlights on stands. Of course, you may wish to construct a much more elaborate setup, but that's not always necessary—even most commercial studios are nothing more than a bare room to which the photographer adds lights, reflectors, backgrounds, and props. Your patience and openness toward your model will do far more to ensure interesting and evocative portrait studies than the most expensive set.

Models who are not professionals will probably feel ill at ease posing in a formal setting unless you work at establishing a positive, relaxed, and active environment. Studio photographers who have begun using autofocus cameras report that the relative simplicity of autofocus allows them to spend more time working directly with the model and less time physically behind the camera. With autofocus you can more easily involve your models in the ongoing process instead of simply making them objects of an exercise.

Often, merely suggesting to a model that he or she switch roles for a bit turns the model–photographer relationship into a dynamic and collaborative venture. On occasion I have asked particularly reticent subjects to move behind the camera and shoot a few frames of me or someone else sitting in their place. Since I was using an autofocus camera set in its programmed, fully automatic exposure mode, the subject had no difficulty snapping a few frames of me, even though she knew absolutely nothing about the camera side of photography. While this is going on, I try to explain what I'm trying to accomplish and ask for their input. Sharing responsibility with the models seems to relax them—it certainly relaxes me—allowing the subject's true personality to come out. A number of successful photographers I know use this stratagem all the time with all portrait subjects, young and old. This cooperative kind of portraiture is one of the most rewarding photo experiences I can think of.

Betsy Wertz

Unusual but very effective mixed lighting is used here—frontal, low floodlight illumination reflected from below and natural sunlight just skimming the back of the subject's head combine for an unusual effect.

This studio shot of model Wanda Jackson uses the ingredients of traditional formal portraiture but with something of a twist. While the lighting and background setups are both rather conventional, Wanda's dress and pose are definitely au courant.

Not surprisingly, hands, although an integral part of the anatomy, are a real problem for many models. To some people hands feel like appendages that don't belong, and nothing these subjects can think to do with their hands feels right. Sometimes a prop such as a flower, book, or pair of eyeglasses gives models something useful to do with hands they otherwise feel awkward about. If you give them something to hold onto, you can literally watch most of their uneasiness evaporate.

Props also serve a further purpose. If a prop is something personal, it may generate some feelings that are then reflected in the subject's face. This added intimacy may be just the thing to turn a routine portrait into something very special. Let your models choose their own prop; direct them to think about what it means to them. Having your model read a favorite passage in a book is particularly effective. Be prepared to shoot while the model is going through the volume or examining the object. It is here that I have also found an autofocus camera invaluable. While I might set up a medium-format camera on a tripod as the principal formal picture taker, during unguarded moments, I reach for the autofocus camera and shoot off several images quickly. It sometimes happens that these private, unguarded moments become solid gold on film.

With my daughter Linden serving as a model, I took this picture in a normal classroom, using only two floodlights. The high angle, pensive look, and a favorite stuffed animal all contribute to the introspective feeling I wanted to capture on film.

LOCATION PORTRAITURE

Shooting on location has some definite advantages as well as a couple of drawbacks. One great thing about location shooting is that you have readymade sets that can add immensely to the authenticity of the pictures. Locations that work well generally tell us something about the subject's work, interests, hobbies, philosophy, home life, political beliefs, or even world views. Locations used to good effect give a much fuller and richer understanding of the individual.

I've found that autofocus is a very productive tool on a location shooting session. When on location, you often need to work fast—far faster than in a studio. Because autofocus can help you get precisely focused images quickly while working on the run, with autofocus many times you can come away with subtle looks and gestures on film that wouldn't be there if you were using a more cumbersome manual-focus camera.

Location shootings often demand you work more rapidly than in the studio. You can't afford to wait. There's just too much going on that you can't control. If you hesitate out in the real world, the image will evaporate before you shoot it. You have to learn to react instinctively.

Jennifer Anne Tucker

PLANNING YOUR SHOOT

Away from the safe, secure, and above all, predictable confines of home or studio, you won't be able to exert absolute control over all the picture-making elements. There is always a chance of unforeseen situations arising, so it is best to plan location shooting very carefully. Make sure you have everything at hand that you could possibly need to complete your work. Henry Sandbank, a very successful commercial photographer, describes planning a location shoot as building a cage around a project and placing everything needed in the cage—photo equipment, props, film, and so on. Thorough planning like this should eliminate all but the most unforeseen glitch.

For professionals, bringing along everything but the kitchen sink is less of a problem than it is for amateurs. Most people who aren't professionals end up making do because they lack extensive equipment inventories as well as the odd bits and pieces pros collect in the course of hundreds of shooting assignments. Also, amateurs usually don't have the brute manpower to help lug all the stuff around.

THE ENVIRONMENTAL PORTRAIT

The environmental portrait is a special kind of location photograph. Environmental portraits are pictures we make of individuals in such a way as to link ideas of who the person is, including what he or she thinks or feels, to a specific environment. The idea here is to tie subject and location together visually and emotionally; the location is not just a pleasantly neutral background.

Making an environment work for you in this way can be difficult. You have to dig into an individual's value system to discover the personality you want to reveal. This can almost never be done casually. As in other portrait situations, it often helps to ask your model for input. You might ask, "If you could be anywhere in this town, where would you be? Why?" or "What place or location gives you the most pleasure? Is there a particular place or activity with which you would like to be associated?" Ask these questions over a cup of coffee or a beer before the session begins.

Always bear in mind that a single portrait cannot ever capture the totality of who someone is. Each portrait, no matter how profound or well done, is only a very thin slice of a multifaceted personality. The best you can do is to offer an evocative impression of someone at a particular time and in a particular place.

This picture, one of many taken for a clothing manufacturer's catalog, sets a tone for the entire product line.

Jim Collins

Photographing in his ancestral Ireland, the photographer used the character of the location to add meaning to this sensitive study of his uncle.

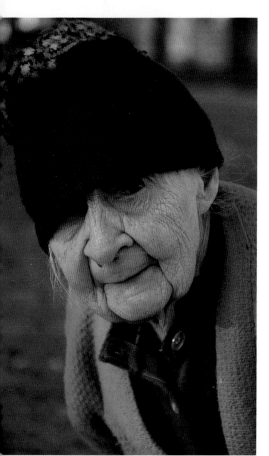

CANDIDS

Candid portraiture is a special form of location photography in which the subject is generally aware of being photographed, probably knows why, and usually is a cooperative partner. However, a candid subject doesn't relate to the camera or photographer as directly as he or she would in a formal setting. What usually happens is that the subject and photographer orbit around each other, not interacting directly. Candid portrait photographers often like to remain outside the activity or event engaging the subject. Shooting from this outside-in vantage point—often using a telephoto lens to maintain physical separation—helps keep the photographer an objective observer as long as the autofocus camera does not search too long for focus and the time lag is short.

What almost always happens is that soon after a session like this begins, subjects forget they are being scrutinized. What results may be a spontaneous portrait that says more than any traditionally arranged portrait possibly could. I've found I can catch fleeting moments of expression better with autofocus than with any camera I've previously used. The advantage is simply that my response time is reduced. While it is very possible that other photographers aren't that distracted by the technical minutiae of manual focusing, I'm afraid I still am. It is especially when I am trying to respond to fleeting expressions or subtle shifts in body position that I appreciate the freedom autofocus confers. I can concentrate on what to photograph instead of on how to photograph.

When I asked the delightful subject of this picture to pose, her hushed response was, "You're going to break your Brownie." Eventually I was able to persuade her to look through the viewfinder and even snap a picture of me. Then I spent the next fifteen minutes shooting a roll while she worked around her yard.

Strong composition, reinforcing shapes, explosive color, and a bit of whimsy figure prominently in the success of this candid shot, one of a series of a rural gas station. It has become something of a tourist attraction because it is one of the last of its kind, a gathering place for the locals.

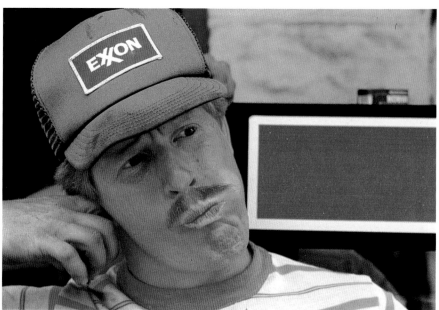

James Collins

Exquisite detail and a very sensitive treatment of the subject came through admirably in this picture, taken with the model's cooperation. Often all that's needed from a subject is a nod of approval.

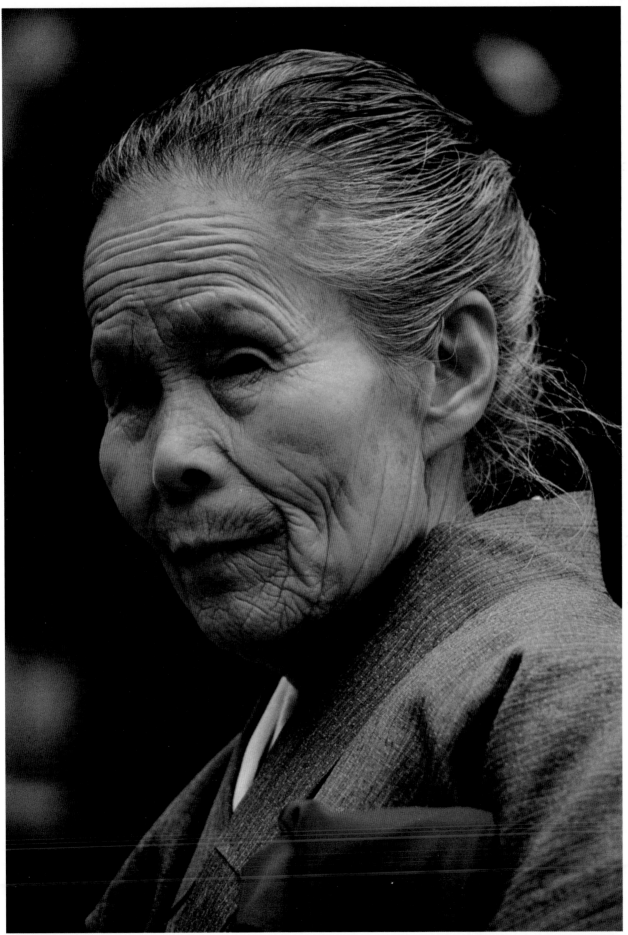

Margaret Williams

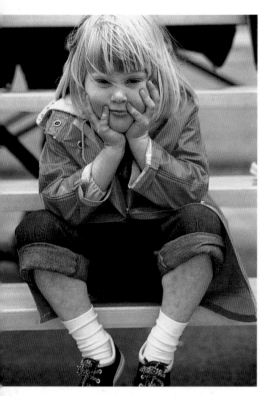

I tried everything to get this cute little girl to smile, but she wouldn't for anything. So I decided to turn my failure into an asset. I got down on one knee and shot her straight on, looking right into the lens.

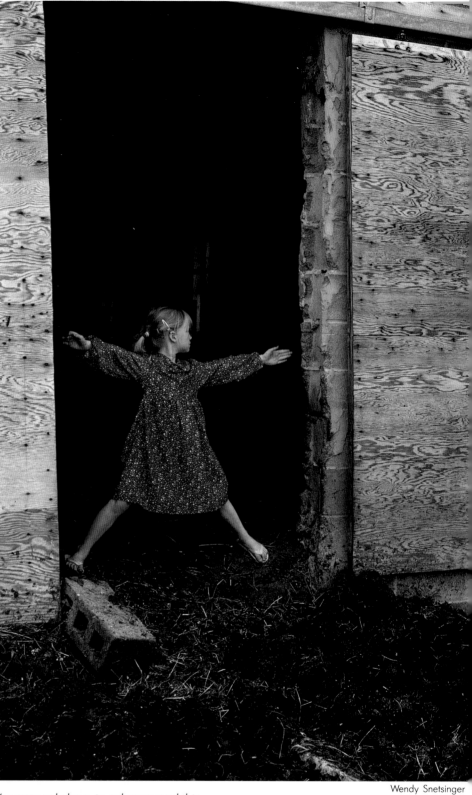

Wendy Snetsinger

You may only have to ask your model to move around randomly to produce an uncommon portrait.

This is a very good example of a cooperative candid. The smiling subject was obviously a fully participating partner. The picture was shot with an early autofocus compact.

KEYS TO SUCCESSFUL PORTRAITS

Here are some things to think about and/or try in your portrait work.

• Try to get your subject to relax. A relaxed subject makes a better model than an uptight one.

• Avoid cuing subjects with directives like "Hold it," "Say *cheese*," or "One more." You contribute to your subjects' self-consciousness too often and the result is wooden expressions.

• Use props, especially when photographing children. If not kept occupied, small children invariably end up with fingers all over lens elements.

• For the most natural look when photographing children, get down to their level. They live in a world of knees.

• Film choice affects overall impression. Learn which color films emphasize warmth or coolness. (See Appendix C.)

• If you have a choice for 35mm work, lenses between 85mm and 105mm offer the most natural perspective for portraits. They also make very good location lenses, combining as they do reasonably high speed and moderate subject magnification.

• Be alert to lens limitations. The wide-angle lenses found on many compact autofocus cameras exaggerate perspective somewhat. Used at their closest focusing distance, these lenses distort perspective—objects closest to the lens seem much bigger relative to what the eye naturally sees than objects farther away.

• Before going "on location" to shoot portraits, anticipate and solve potential problems in advance as much as possible.

• Consider your objective. Traditionally, the goal of a portrait photographer was to show the subject to best advantage. Contemporary portraiture places more emphasis on highlighting something of the subject's character or beliefs, with less emphasis on perfect physical presentation.

Jennifer Anne Tucker

PHOTOJOURNALISM

Although photojournalism owes much to candid portraiture, it is very different in a number of respects. First, photojournalists look for images that tell a story in a certain way. The images can't be too subtle and, unless they are part of a larger essay, must be completely self-contained. No matter how aesthetically appealing or technically correct, any documentary image, especially one including people, must contain newsworthy elements. Otherwise it will never be published.

More than any other form of the photographer's craft, documentary reportage and other street work require making quick, instinctive decisions and an ability to shift rapidly from one subject to the next in a wide variety of lighting conditions. It's absolutely essential that photojournalists or those who choose to take pictures using a reportorial style be totally confident of their equipment. Their cameras and lenses must help them react instantly to fast-breaking events. In this regard, photojournalism is much like sports photography.

Photojournalism entails a special way of operating behind the camera. It is more aggressive—and some claim more objective—than other forms of photography, especially formal portraiture. A photojournalist's goal is not to glamorize subjects but rather to show what is newsworthy about them. Similarly, if you want your camera to catch images of the street, your goal will probably not be to idealize what you see but to capture your visual impressions on film, no matter what they are. Flavor and content are what you are after, and if the flavor is disagreeable your pictures should reflect that.

When a picture possibility presents itself and is essentially positive, I don't hesitate. Here the photographer made the same judgment.

Margaret Williams

What I wanted was a picture that would support my feelings about all Irish kids. I was after impressions of smooth, rosy cheeks, lots of curly hair, and freckles, but I didn't want the sharp detail of a normal image. The problem was solved when I let the little boy in the picture move through the frame at an exposure of about 1/15 sec.

Adopting a photojournalistic approach sometimes entails an element of risk not present in other modes of photography. Since it is generally more intrusive and subjects often are not cooperating partners, there are serious legal, ethical, and personal safety issues to consider. I've found one piece of advice particularly helpful here. Whenever possible, let the people you intend to photograph know what you are about to do and why. This is particularly important in large urban settings. In some neighborhoods, letting the cop on the beat know what you are doing can provide a welcome margin of safety. I am not telling you this to discourage you from attempting street work—merely to help you avoid potentially sticky situations.

Because photojournalists commonly work from the outside in, they mostly prefer longer-than-normal-focal-length lenses. High-speed, moderate telephotos are their particular favorites. These lenses provide two important advantages: (1) They are usable under a wide variety of lighting conditions,

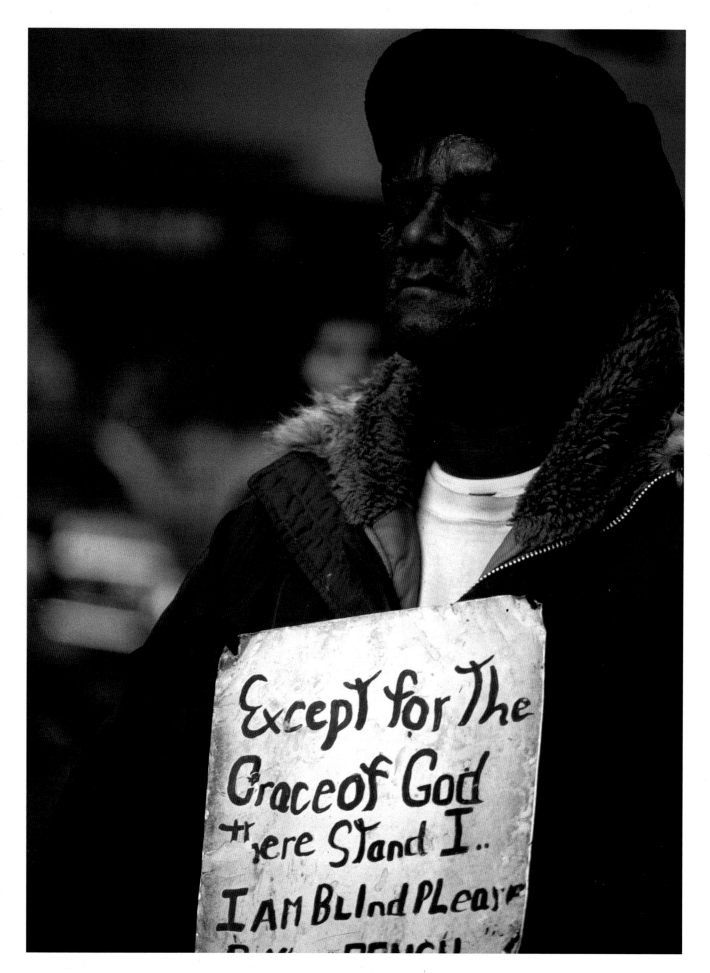

and (2) the moderate telephoto effect delivers normal perspective while maintaining a workable distance between photographer and subject.

You can understand then why compact autofocus cameras with their wide-angle lenses are not particularly popular with experienced street photographers. Street photographers and some photojournalists are choosing 35mm autofocus SLRs. They like the lens flexibility and variety, the direct through-the-lens viewing, the fast, accurate automatic metering, and the quick, precise autofocus. Street shooters can operate the versatile autofocus SLR as a very sophisticated point-and-shoot camera, but one with very high-quality lenses and flash systems. And since most autofocus SLRs can be operated manually, they are flexible enough to deal with almost any picture-taking situation you might encounter.

As with other aspects of autofocus photography, planning and selecting your perspective or vantage point is very important. Vantage point on the street or at a fast-breaking news event often determines whether a picture will be okay, good, or outstanding.

STREET SHOOTING

For professional photographers who normally work for newspapers and magazines, the ethics and legal principles governing on-the-job behavior are determined by precedent. Although there is no unanimous agreement to this effect, amateur photographers as a rule have less legal standing than professionals. Clearly, there are limitations beyond which you may run into legal quicksand. Here are a few situations to avoid:

- Using a picture of a person to sell something without his or her consent

- Exhibiting or publishing a picture that makes someone look bad

- Taking honest but private or embarrassing pictures of individuals without their consent

Should you ever anonymously shoot a picture of anyone on the street? Are you within your rights and is it safe to photograph anyone from whom you don't have prior permission? Before you put your camera away on the top closet shelf, consider how the courts have responded to cases involving privacy. As a rule, they have defined privacy very narrowly and, with the exception of physical invasion of private property, harassment, or commercial use of unauthorized pictures, they have upheld the photographer's rights to shoot pictures of people in public without their consent. Professional photographers probably enjoy greater leeway under the law than do amateurs simply because a professional has more reason to be taking pictures of newsworthy events. The bottom line is that you can take most street or public pictures if you use a little common sense on how they are eventually used.

Street shooting is not necessarily limited to professionals or even advanced amateurs. Many individuals with compact autofocus cameras will be tempted to turn into street shooters when they are traveling. Everyone is a bit apprehensive about street shooting at first, but as you become more experienced, you'll become more comfortable.

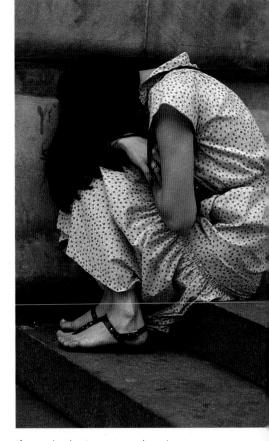

If people don't agree to be photographed, what should you do? You have to develop your own ethics and sense of approach. I didn't have much of a problem shooting this image, but a fellow photographer with me did.

Shot in Manhattan a few years ago, this scene is typical of street shots I take to tell a specific story. This image was one of several I took to show that individual dignity can be maintained even when things are not ideal.

THE PHOTO ESSAY

There comes a time in the life of all photographers when they entertain notions of creating an extended photo piece—a photo essay—whether for publication, exhibition, or personal use. Regardless of what is intended for the essay, it helps to know a bit about design and layout before beginning. (Several good references on the subject are noted in the bibliography.) Above all, an effective photo essay needs a theme to bind it together and give it a unified appearance. Stories can be organized in many ways. A few of the most common organizational principles used are chronology, problem solution, case study, and analysis of aspects of a single event.

Key Pictures. There are at least three more or less mandatory kinds of pictures in most photo essays: (1) an overall shot or two showing the entire scene or environment within which the story takes place, (2) a set of photos providing a closer, all-encompassing look at important aspects of the subject matter and relating most of the story, and (3) one or more closeups featuring visual detail with a direct bearing on story content. These closeup images add spice to the visual stew and give the story its character.

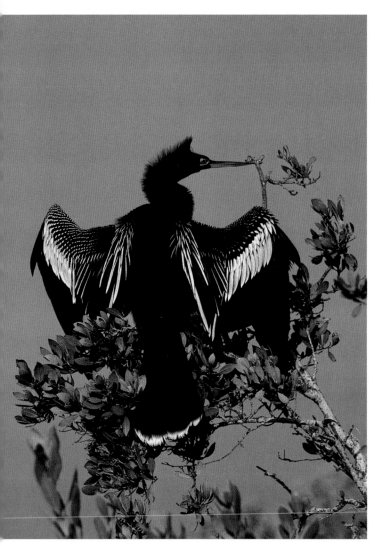

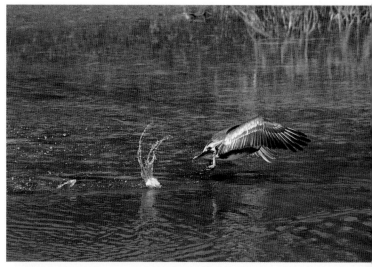

Layout and design decisions must be worked out carefully because even the most profound pictures will lose much of their appeal if presented with indifference. Here are some guidelines to follow when selecting pictures for an essay:

- Be sure that each picture tells something different about the subject.

- Choose one picture with a lot of emotional appeal to organize your other images around. This picture can be very large in relation to the others.

- Crop out all unessential parts of pictures—clean, graphic images work best in multi-image presentations.

- Try to select diverse images, both strong verticals and horizontals. Use pictures of different sizes as well.

- Lay out a dummy page or board to plot the arrangement of pictures. Try to allow enough space between pictures (called white space) to set each one off but not so much as to isolate them. This is a somewhat tricky business, but you'll be surprised how well your instincts will guide you here. Study how magazines like *Life* lay out a photo story.

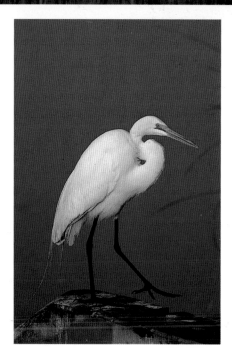

If the essay is for exhibition or home display, select framing very carefully. The right framing technique will help highlight the work. The best rule I've heard is to use as inobtrusive a frame as you can get away with.

COMMERCIAL CONSIDERATIONS

Commercial photography includes more than just portraiture and photojournalism. Photographers also supply images used for advertising, editorial, technical illustration, scientific and industrial, and fashion purposes, to name just a few commercial applications. The chief consideration in virtually every case is that the photographer, working for money, must deliver a product that suits someone else's needs. Often professionals cannot afford to indulge their own creative impulses and find themselves drawing distinctions between creativity and proficiency. However, this is not always the case, and many highly imaginative and pioneering photo styles have emerged from the commercial arena.

Except for scientific, industrial, or photojournalistic applications, most commercial work is done to sell something. Most of the time that something is not the product *per se* but a preconceived idea illustrating what it means to

Commercial glamour shots that are tastefully done can still be exciting. Incidentally, this is one of the first autofocus pictures I ever took. I made it with a very early, first-generation point-and-shoot compact.

Jason Jones

Advertising accounts for a major portion of many a commercial photographer's income. Although commercial photographers usually work to someone else's ideas, the results are generally interesting, sometimes even brilliant. Commercial photographers will probably demand manual override on autofocus cameras before they will accept them fully.

use a product or service. The same holds true in the corporate/industrial arena. Photographers usually busy themselves illustrating themes, and these themes are generally part of a larger image-building effort involving all facets of corporate-public contact. Photography is increasingly being used to project dynamic and sometimes very cleverly designed corporate themes.

Fashion is yet another industry where photography plays a pivotal role. While you might take exception to some of the underlying messages contained in modern fashion illustration, the photography itself includes some of the most creative and innovative work being done today.

Fashion is a dynamic activity often requiring quick responses to a fleeting glance or position. Constant reshooting can be costly and frustrating. While I am not suggesting that autofocus can totally eradicate these problems, it can provide fashion photographers with a formidable instrument for tackling them.

As the autofocus response to rapidly moving subjects gets better, more and more photojournalists will use this equipment. Because the newest autofocus SLRs are completely electronic, there will be a natural inclination to find computer tie-ins for remote or scientific applications. Autofocus technology hasn't had a major impact on commercial photography just yet, but I am persuaded that, together with through-the-lens metering and the single-lens reflex camera itself, autofocus will come to be essential for the pro in the not too distant future. It is inevitable. Any tool incorporating a technology that can help professionals work quicker and more responsively and can save time to boot saves money.

7 DEVELOPING A STYLE

As you begin to take photography more seriously, you'll want to find some way to evaluate your picture-taking prowess. From the preceding chapters you have ample evidence that getting better is no longer a matter of becoming technically competent. Historically, many critics judged the worth of a photograph by measures that rated the technical proficiency of the photographer. This situation, where technique is an important factor in criticism, presents an interesting problem for serious autofocus camera users.

Because you and I choose to use cameras capable of delivering a high percentage of technically correct images with little or no help from us—even to the extent of the camera making qualitative judgments about atypical or difficult lighting conditions—we need to adopt revised standards for judging our work. I think it no longer practical or even desirable to rely on technical measures so heavily, although technical excellence in a photograph is always preferable to indifferent execution and remains a factor to be considered. Rather than judging ourselves primarily on technical expertise, we can return to what I believe is a better measure of a good photograph—how well it communicates and to what extent it reveals a unique vision.

Judging pictures in this way has a number of advantages. It allows us to apply criteria fitted to the photographer's intent. For example, if all we wished to create was a record of Aunt Jane's eightieth birthday, we can judge the result accordingly. If, however, the goal was to share something of my deep affection for Aunt Jane, a simple snapshot documenting the event will probably fall short of the mark.

It's logical to get away from the idea that there are objectively good and bad pictures. To my eye, there are only pictures that make a connection between photographer and viewer and those that don't. Some "bad" pictures work very well communicating feelings or events although they lack technical merit. Conversely, technically correct or "good" pictures (by old, conventional standards) often fail miserably to promote the sharing of any ideas, feelings, or information. Even though they are well executed, they present nothing unique to excite the viewer.

I couldn't spend much time focusing this image because it was shot from a car window. I doubt I could have made this picture with a conventional camera.

WHAT DO YOU WANT YOUR PICTURE TO SAY?

Sharpening your observational skills leads to more interesting pictures and can also help you become a reasonable critic of your own work. Someone once said that great pictures most often occur when you engage your brain *before* engaging the shutter release. Thinking about what you see in the viewfinder and what you want someone else to see in your pictures is the first step.

All too often, a photographer looks in the camera's viewfinder without trying to understand what is there, and the pictures that come back demon-

strate this visual indifference. It's not necessary to engage in an extended thinking exercise to change this. Asking yourself just a few pointed questions will make the difference—What am I looking at? Does it mean anything to me? Is there anything I want this picture to say? You may be asking these questions already without realizing it. The problem is that you may be asking them after you get the pictures back from the photofinisher and not before taking them, when you should.

Not every photograph needs to have a precise meaning, even to the person who took it.

Bob Baumbach

I'm struck by the wonderfully luminous quality of this picture. What makes it even more intriguing to me is its abstract nature. Identifying the literal subject of a photograph isn't important as long as it produces an emotional reaction.

Getting better is very much a matter of coordinating your mind, eyes, and hands and adopting a looking-thinking-seeing-shooting sequence in your picture taking. Thinking is the key. What thinking does is help you edit what you see down to an essential message, or what some have termed the *residual message*. The residual message concept is simplicity itself. As a rule, every bit of human communication, and especially the visual stuff (films, television, graphics, and photographs), contains only one or two messages that people actually take away with them or remember. The residual message is what people remember after they forget everything else. So the question to ask is, what do you want people to remember from your photograph?

The deceptively simple but powerful bit of information provided by the above answer to this question can reshape the way you look at potential photo subjects. Use it to give direction to your visual editing. When you look at a potential subject, look for your residual message—the one or two impressions you want to leave with the viewer. Then let all your other decisions flow from it.

ACTIVE SEEING

Sounds fine so far, you say, but how do I apply this approach to everyday shooting? The answer: by practicing *active seeing*. Here it is in a nutshell: Something catches your eye . . . you look through the viewfinder. At this point most of us would probably spend a bit of time to compose and then shoot. But here's where active seeing comes into play. *Before* composing, really look at the scene and ask yourself what it is you see. Try to distill your impressions into a few words. Determine what attracted you to the scene. It could be any number of things: interesting tones, vibrant color, strong lines, shapes, unusual textures. If you are studying a portrait subject, identify the characteristics that convey the residual message. Identifying and then high-lighting a particular expression, posture, or physical quality can be enormously effective.

When people look at this picture, they either get it or they don't, and that is some of the fun for me. I love to show this picture to a group, then sit back and catch the reactions.

The photographer who took this picture liked the vivid color combinations enriched by the soft, indirect lighting of an overcast day. He composed carefully to include only necessary design elements in this study of form.

It is particularly important not to be too ambitious, especially in portraiture. Strive for one or two memorable qualities. Don't be surprised if these change from one observation to another. Remember, observation is not an absolute science. It is very subjective. Even though active seeing sounds like a lengthy and complex process, the more you practice it, the quicker you get. Some photographers don't actually realize they're engaging in active seeing, but their pictures certainly show its results.

Is becoming a more active observer the only thing you need to get better? For a few photographers, yes, but not for the rest of us. Learning techniques for active seeing is but a first step. You should devise a way to get useful feedback on a regular basis, whether formally or informally. There is probably a camera club within a one-hour drive from virtually everyone reading this book. Most of these clubs sponsor regular members' photo competitions or critiques that you can participate in. While I'm not a particular fan of photo competitions, you can use them to get valuable feedback from a variety of sources: invited judges, teachers, and other club members. As long as you don't accept the verdict of these subjective observers as gospel or get overly caught up in competition *per se*, you'll be all right. Remember, winning doesn't necessarily mean you are getting better. It may only mean you've learned how to take pictures that win contests.

You could also take photographic courses either through local colleges or adult education programs. An advantage to this approach is that you'll rarely find yourself in head-to-head competition with your classmates. A good instructor will encourage your growth while at the same time pointing out areas needing work.

You can get helpful feedback simply from sharing images with interested friends or colleagues. Sharing lets you solicit input from others who can approach your pictures from many perspectives. It is gratifying and often confidence-inspiring to find that your work has meaning for someone else. To aid your own development of perspective, find out how other people would approach your subject if they were taking the picture. I advise you not to take negative comments personally, and don't gloat over praise. Your purpose is not to garner praise or avoid censure; it is to open your own eyes to new ways of seeing things. The bottom line is that asking for input from people whose opinions you value will give you a pretty good idea of whether you are communicating well and may elicit welcome suggestions on new approaches to explore.

Bill Gourley

Still-life photography provides a luxury—time to ponder. It is important to engage the subject simultaneously with mind and eye. I think it is possible to find out who photographers are through their pictures.

LEARNING THROUGH THE WORK OF OTHERS

It is possible to learn a great deal by studying the work of photographers you admire. Their images will introduce you to new and exciting subject possibilities, unique points of view, or ways to strike out into new areas of photoexpression.

Of course, personal growth does not occur by adopting someone else's style wholesale. Rather, the value of studying another's work lies in identifying his or her unique vision and adapting it to your own way of seeing. By doing this you add to the variety of ways you can approach any photo subject. Think of the study of other photographers' work as a good way to acquire greater visual awareness.

As you look at other photographers' pictures, decide what special techniques, perceptions, or philosophy their pictures reflect. Moving from one to another, you'll soon see that there are an unlimited variety of picture-making perspectives available to keen observers. Take what you find valuable in other people's work and make it part of your own learning and growth.

To help you tune into other perspectives on picture taking, I've chosen to introduce you to five different photographic styles. These are personal favorites of mine; however, I've included them here because they represent a good cross section of photo practice, past and present. Please note that these five approaches do not even remotely represent the full range of photographic style and practice. They are but five that have taught me a great deal. The first two approaches, the external-reference and the intimate styles, represent different modes of seeing. They both chronicle the human condition but from vastly different perspectives. The remaining three involve approaches to color photography.

Adherents of the philosophy of the "decisive moment" will probably appreciate the unique vision presented in this quiet, touching image. Its outside-in vantage point is one they most likely employ themselves. All elements appear in perfect order. This is a fine example of a picture in which the photographer's sensitivity to subject comes through emphatically.

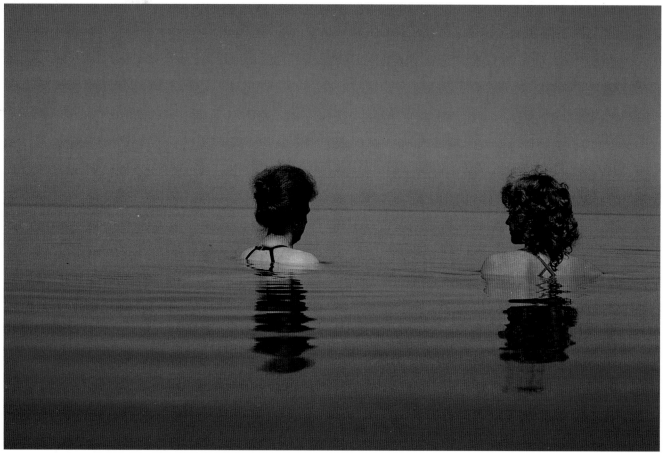

Marion Deppen

Over the course of the past twenty-five years, color photography has boomed. This growth has been attributed to strides in color-film technology, mechanical and electronic innovation in camera designs, and increased speed and automation in color processing. Presently, millions of part-time photographers routinely shoot color, producing billions of high-quality photographs. Current figures indicate that over 80 percent of all photographs taken worldwide are in color, yet few photographers have managed to tap the full range of expressive potential inherent in the color palette. Even among professionals, only a handful have seized the opportunity to use color in a way that sets their photographs apart from the myriad of lookalike images we see every day. In the approaches to color described below, color is not used as just another tool; instead it is treated as the dominant visual force in the photograph. All three color styles share a common goal: to use color to create strong emotional appeal.

The External-Reference Style. This style involves viewing events from an external vantage point, looking in at the photographic subject from "the outside." The photographer tries to remain somewhat detached and apart from the events or subject, but not to the point of being unaware of what is unfolding before the lens. Photographers adopting this operating style generally like to remain unobtrusive as they wait for their subject, light, and composition to come together in a "decisive moment."

Shooting from the outside-in allows a degree of both personal and psychological safety. Typically, photographers choosing this mode work with relatively fast film and telephoto lenses so they can take advantage of the available light and use their long lenses to bring them into intimate contact with their subjects, yet remain physically apart. Practitioners of this kind of photography try to recognize the significance of an event and simultaneously to give it proper photographic expression. In effect, when all the picture elements fall together to create the desired images, the photographer says, "Aha! there it is!" and gets it on film.

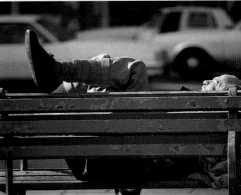

The Intimate Style. In some ways, this style represents the opposite end of the spectrum from the outside-in vantage point. It is not so much that the resulting pictures are so different, although they frequently are; it is more a matter of difference in how photographers choosing either style think of their role.

While external-reference photographers stay apart from the events they capture on film, others prefer to involve themselves intimately with the events and people they photograph. Many live, work, and even suffer along with their photographic subjects. For these people, photography is an intimate experience and needs to be done from the inside. Instead of taking a nonpartisan, uninvolved stance, they operate from a position of committed advocacy, using pictures subjectively to express their most strongly held beliefs. Photographers who work in the intimate style insist this immediacy generates visual energy. They feel it is totally appropriate for a photographer to interpret events closeup and subjectively.

Obviously, it is for you to judge which style you prefer. It is not a matter of one being right or wrong. Think about each operational philosophy—the more objective, patient external viewpoint and the subjective, high-energy emotion-driven style. From which do you see yourself operating? Why not the other? Maybe you will find yourself working to some extent between these styles, and that is all right, too.

This candid sequence is very intimate. I watched this fellow for more than half an hour before finally going over to him and chatting. One thing led to another, and finally I told him I was a photographer. He turned out to be a veteran who lived on the street full time.

Beginning with a straight shot of power-transmission lines, this professional photographer modified the image with filtration until it elicited exactly the feeling he was after for a predetermined corporate application.

Color Image Making. This is an approach to color involving an operational style that assumes the original slide or negative is just the beginning point in the series of steps leading to a final image, much as a painter begins with sketches of a subject. By employing slide or negative duplication with extensive filtration, color image makers can transform an original into a vastly different and highly stylized vision. Color can be deeply saturated and vivid or soft and delicate, depending on the mood desired.

Many of the better-known devotees of this style of color usage produce strong, bold color with an intense quality not unlike that common in posters or silkscreens. Most of these pictures have what the noted photography writer Andreas Fenniger calls "stopping power," a quality that makes the image all but impossible to ignore.

For those constructing their own images, color and form can be totally subjective. They often use unconventional, surprising, and sometimes arbitrary color combinations to give added visual punch to ordinary objects. These image makers are closest to traditional painters of all the photographic practitioners.

Color Picture Taking. Like the image makers, picture takers accept color as the central force around which other elements—exposure, composition, and perspective—revolve. However, they differ in one specific way: Most of their creative energy is directed to the picture-taking process itself. Original transparencies or negatives contain most, if not all, of the elements necessary to create the final image without additional manipulation. For these photographers, camera technique and on-the-spot inspiration are all important. Often, photographers develop individualized techniques or viewpoints that add a new dimension to the philosophy of seeing. They may choose to work with a select portion of the color palette—for example, emphasizing high-key, pastel renderings of subjects, or exploiting the effects obtained by blurring and mixing colors at very slow shutter speeds. However, in either instance the innovation takes place at or near the exact moment the picture is taken. In other words, the first-generation image is most often the last as well.

This picture is a created image, to be sure. It started as a "what if?" In this case, I placed a blown slide-projector bulb in front of a Christmas tree and moved various lights in and out, some closer, some farther away.

There are those who argue that color photography is by its very nature less demanding than black and white because the color saves mediocre images that would fail in black and white. To the undiscerning this may be so. However, we now see so much color that color itself no longer wows the viewer. It's no longer enough for an image to possess smashing colors. For any image to communicate well, it must also have substantial content and be expertly executed. In this picture, a combination of ambient light and flash outdoors created a striking effect to complement the content. Lighting, dramatic sky, and the all-time-favorite '57 Chevy blend together to leave a nostalgic feeling of days gone by but not completely forgotten.

The Intimate Approach to Color. This approach to color involves presenting the subject with startling clarity and detail. It is much like an earlier style of black-and-white photography named the *f*/64 School, supposedly because of the extremely small *f*-stops the school's adherents used to produce rich detail and texture. The intimate approach to color entails the creation of images in which a premium is placed on detail and uniform sharpness from the center to the extreme edges of the picture.

Much of the best intimate color work takes nature as its subject. By selecting small but representative samples of far larger subjects to photograph, adherents of the intimate mode attempt to persuade us to appreciate the lush detail they see there. They offer the viewer texture, light, color, and form, all finely etched. Usually color is very subtly integrated into the total image plan, often emphasizing the natural order in various shades and tints of just one color. For photographers who practice the intimate approach, everything—color, composition, light—has a sense of correctness about it, natural in its proper place and in the appropriate intensity.

EVOLVING A PERSONAL STYLE

Style has little to do with what autofocus camera you choose to use. Style has to do with how you approach your subjects and what you try to communicate about them through your pictures. Your individual style will emerge and evolve naturally if you don't mimic other photographers, but instead learn from them. If you study your own pictures and let other people comment on them, you'll come to understand the unique way you see things.

Here are a few summary guidelines to remember. I believe they will help you recognize when you do get better. Also, they should help you evolve a style all your own.

• First and foremost, begin by shooting what you know best.

• Don't resort to gimmicks unless you have a sound creative reason for doing so. Soft focus, multiple images, intentional blur, freaky color, etc., are only effective if they support an overall theme.

• Try to determine your color and compositional keys. Each of us probably has a few colors or combination of colors and certain physical patterns or shapes we prefer. We return to them time and time again. Right now, mine are red and yellow, and my compositional key is a triangle. Both keys change for all of us from time to time. Perhaps an awareness of these keys can prevent us from developing a sameness in our work.

• Determine whether you are more comfortable photographing from the outside-in or from the inside. Then practice the other to expand your photographic perspective.

• Choose the equipment and film that work best for you, not what the so-called experts say you should be using.

• Assuming the residual message is the essential communication of any photograph, it may be the place to begin. Keep in mind that it is probably the only thing people looking at your pictures will remember.

• Engage your brain before you engage the shutter release.

<div align="center">Always think before you shoot!</div>

APPENDIX A

LIST OF AUTOFOCUS EQUIPMENT EMPLOYED IN THE PREPARATION OF THIS BOOK

COMPACT AF CAMERAS
Minolta Freedom III
Minolta AF TELE
Fuji DL 300
Fuji TW 300
Pentax IQ Zoom

AF 35MM SLRs

Minolta
Maxxum 9000
Maxxum 5000
Flash AF 4000

AF Lenses
20mm AF
28–85mm AF
135mm AF
70–210mm
50mm AF macro

Canon
650 EOS
Flash 420 E2

AF Lenses
EF 50mm
EF 35–105mm

Sigma
AF Lenses
AF 28–200mm
AF 75–300mm
AF 400mm

APPENDIX B

CHARACTERISTICS OF COLOR FILM

PRINT FILM

Primarily designed to produce prints from negatives, print film has great exposure latitude, and quality of pictures depends on fresh chemicals, accuracy and programming of printing equipment, and/or skill of individual printers.

SLIDE FILM

After standard processing, a slide transparency can be considered a finished product although many people choose to go one step further and make prints from selected slides. Slide films vary in color rendition, contrast, and saturation from brand to brand and even within brands from one specific film to another. What follows is an assessment of slide film intended for daylight use, arrived at by extensive use and subjective evaluation.

COLOR RENDITION

BLUE BIAS	**NEUTRAL**	**YELLOW OR MAGENTA BIAS**
Ektachromes (new versions less blue than in the past)	Scotch Konica Fujichrome	Kodachrome Agfachrome

CONTRAST*

LEAST CONTRAST	**MODERATE**	**MOST CONTRAST**
Agfachromes (especially Agfachrome 100)	Scotch Ektachromes Fujichrome 100 Konica	Kodachrome 25 Fujichrome 50 Kodachrome 64

COLOR SATURATION CONTINUUM

LEAST SATURATED ⸻⟶ **MOST SATURATED**

Agfachromes/Scotch/Konica/Ektachrome/Fujichrome 100/Kodachromes/Fujichrome 50

*Low-contrast film records subjects with a wide range of middle tones and hues, with few bright highlights or dark shadows. It also tends to emphasize pastels. High-contrast films perform in reverse, producing more saturated, snappy color.

BIBLIOGRAPHY

Aaron Siskind: Places—Photographs 1966–1975. New York: Farrar, Straus & Giroux/Light Gallery, 1976.

Adams, Ansel. *The Portfolios of Ansel Adams.* Boston: New York Graphic Society, 1977.

Albers, Josef. *Interaction of Color* (2nd ed.). New Haven: Yale University Press, 1983.

Andre Kertesz. Aperture History of Photography. Millertown, N.Y.: Aperture, 1977.

Bailey, Adrian, and Adrian Holloway. *The Book of Color Photography.* New York: Alfred A. Knopf, 1979.

Cartier-Bresson, Henri. *The Decisive Moment.* New York: Simon & Schuster, 1952.

Caulfield, Patricia. *Capturing the Landscape with Your Camera.* New York: Amphoto, 1987.

——————. *Photographing Wildlife.* New York: Amphoto, 1988.

Coleman, A. D. *Light Readings.* New York: Oxford University Press, 1979.

Ducrot, Nicholas, ed. *Andre Kertesz: Sixty Years of Photography.* New York: Viking, 1978.

Edward Weston: His Life and Photographs. Millertown, N.Y.: Aperture, 1975.

Edwards, Betty. *Drawing on the Right Side of the Brain.* Los Angeles: J. P. Tarcher, 1979.

Eugene Atget. Aperture History of Photography Series. Millertown, N.Y.: Aperture, 1980.

Freeman, Michael. *Achieving Photographic Style.* New York: Amphoto, 1984.

The Great Photographers. Life Library of Photography. Alexandria, Va.: Time–Life Books, 1972.

Gregory, R. L. *Eye and Brain.* New York: McGraw-Hill, 1967.

Haas, Ernst. *The Creation.* New York: Viking, 1971.

——————. *The Face of Asia.* London: Thames & Hudson, 1972.

——————. *Himalayan Pilgramage.* New York: Viking, 1978.

——————. *In America.* New York: Viking, 1975.

——————. *In Germany.* New York: Viking, 1977.

——————. *Man and Machine.* New York: IBM World Trade Corp., 1969.

——————. *To Dream with Open Eyes.* Minneapolis: Media Loft, 1980.

Hattersley, Ralph. *Discover Yourself Through Photography.* Dobbs Ferry, N.Y.: Morgan & Morgan, 1976.

Hedgecoe, John. *The Art of Color Photography.* New York: Simon & Schuster, 1978.

——————. *The Book of Photography.* New York: Alfred A. Knopf, 1976.

Henri Cartier-Bresson. Aperture History of Photography Series. Millertown, N.Y.: Aperture, 1976.

Jerry N. Uelsmann: Silver Meditations. Dobbs Ferry, N.Y.: Morgan & Morgan, 1975.

Karsh, Yousef. *Karsh Portfolio.* Toronto: University of Toronto Press, 1967.

Kertesz, Andre. *Distortions.* New York: Knopf, 1976.

Kobre, Kenneth. *Photojournalism: The Professional Approach.* Millertown, N.Y.: Aperture, 1980.

Langford, Michael. *The Master Guide to Photography.* New York: Alfred A. Knopf, 1982.

Levey, Marc B. *Photography: Composition, Color, Display.* New York: Amphoto, 1979.

——————. *The Photography Textbook.* New York: Amphoto, 1980.

——————. *Thinking in the Photographic Idiom.* Englewood Cliffs, N.J.: Prentice Hall, Inc., 1984.

INDEX